Ciao, Carpaccio!

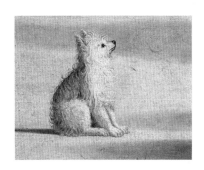

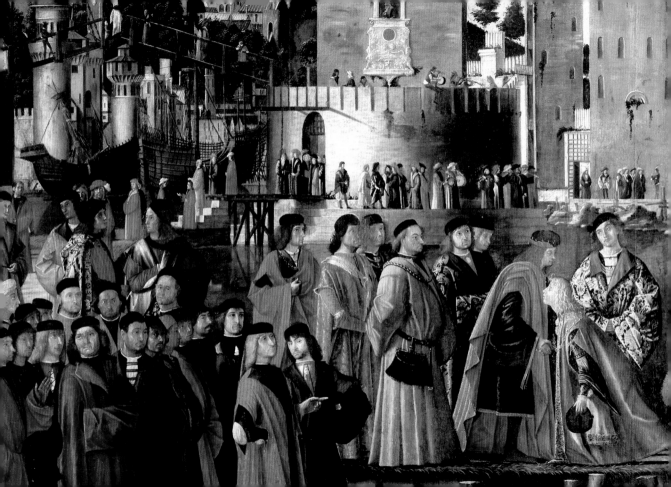

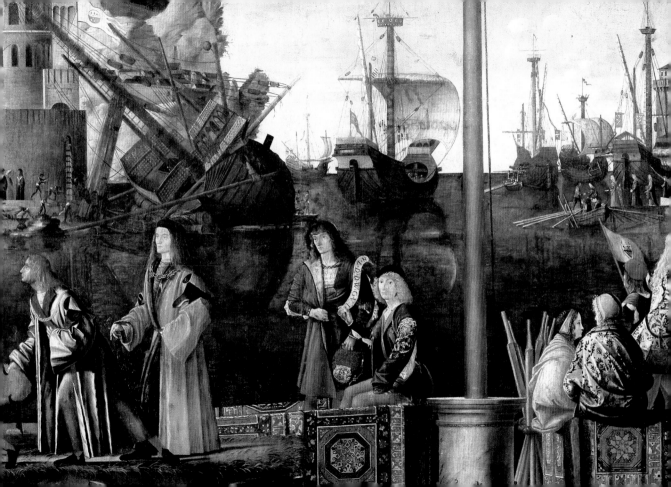

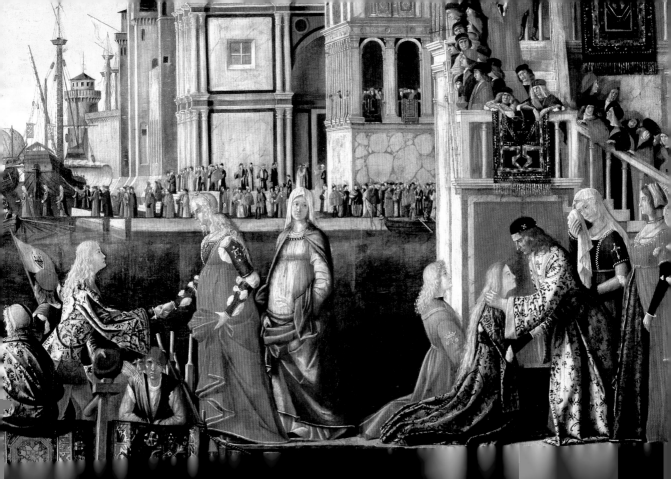

Ciao, Carpaccio!
An infatuation

Jan Morris

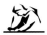

LIVERIGHT PUBLISHING CORPORATION

A Division of W. W. Norton & Company London–New York

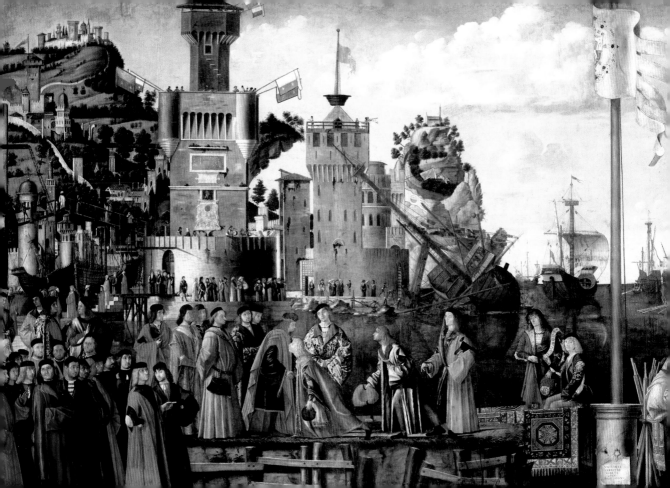

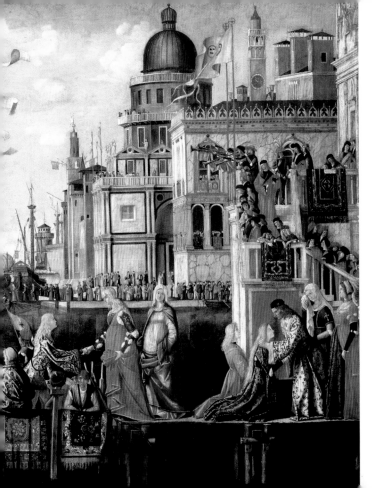

Contents

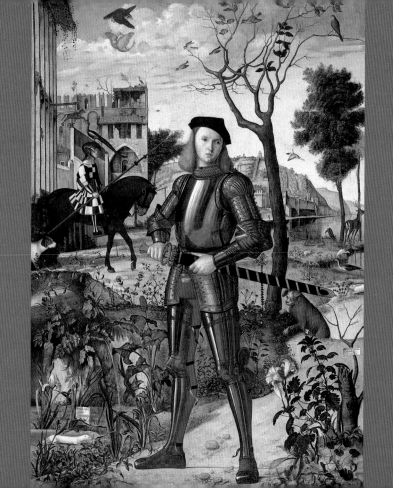

Introduction

After a good dinner one evening, with excellent company and a bottle of wine, I settled by my fire with a volume of paintings by the 15th century Venetian painter Vittore Carpaccio. For much of my life I have been under the spell of this artist. I am no connoisseur, cultural scholar or art historian. I know nothing about painterly techniques, chromatic gradations or artistic affinities, and my infatuation with him is largely affectionate fancy. I feel I know him personally, and I often sense that I am directly in touch with him across the centuries, across the continents, as one might be in touch with a living friend.

Meandering that night among Vittore's pictures, in an agreeably flexible frame of mind, I came across the study called *Portrait of a Young Knight* which hangs in the Museo Thyssen-Bornemisza in Madrid. It depicts, against an exuberantly imaginary background, a diffident youth in full armour, apparently about either to draw his sword from his scabbard, or to sheathe it. He has been variously identified down the centuries as Ferdinand II of Aragon, a Duke of Urbino, a Habsburg prince, a German mercenary soldier, a member of the Neapolitan Order of the Ermine or (least probably, in my opinion) the legendary Roman general St Eustace, who was

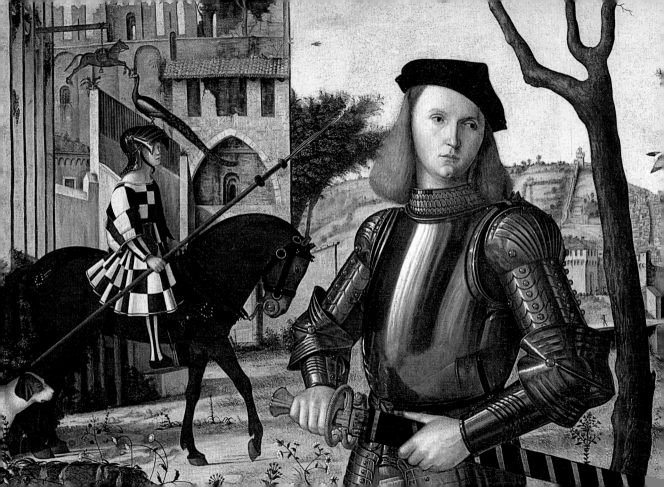

converted to Christianity by a vision of a stag with a luminous crucifix in its antlers. An inscription on the picture reads MALO MORI QUAM FŒDARI, which means that it is better to die than to be sullied, and is I am assured the national motto of Brittany *(Kento'ch mervel eget bezãn saotret)* and the regimental motto of the British Army's Royal Regiment of Wales *(Gwell angau na Chywilydd).*

Behind the knight, who looks pale, is an adolescent horseman on a black charger. He is probably the knight's squire, and above his head hangs, like an inn-sign or a craftsman's advertisement, the cut-out metal silhouette of a horse. All around is a garden of delectable wild flowers. This is inhabited by a peculiar menagerie – hares, frogs, white rabbits, two lugubrious dogs (one of them glowering resentfully behind the knight's back), a meditative stag (antlered but not luminous), a peacock, a stork with chicks, a particularly horrible vulture, an egret, a black falcon fighting a heron and a

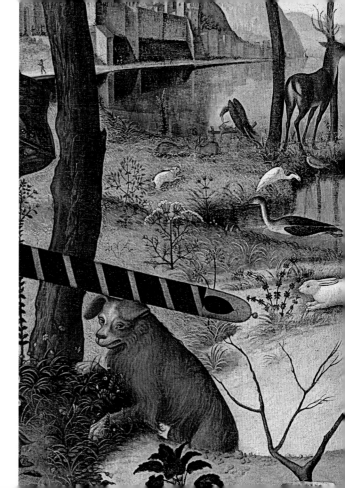

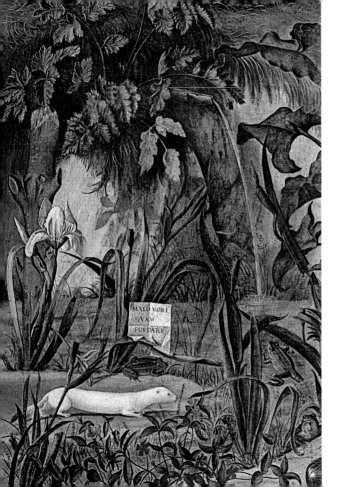

sleek white ermine. What is it all about? Many of those creatures undoubtedly play symbolical roles in the composition, signifying for scholars badness or goodness, purity or corruption, but for me they simply add enigmatic delight to a scene of queer enchantment.

The sky in the background of the scene is punctured by the battlements of a castle, by a tree or two, by the stork's nest; and that evening by my fireside I happened to notice a little blob, towards the top of a leafless twig, all alone against the empyrean. I magnified the image on my computer screen, and as it gradually came into focus first the edge of a cloud revealed itself, then the twig itself, and finally that blob was resolved into the presence of a solitary small bird. It was a woodpecker perhaps, or a jay, cheerfully multi-coloured, I liked to think (for to be honest it was hardly more than a smudge), sharp-beaked, watchful, possibly a little mischievous, surveying all unnoticed the weird *mise en scène* below.

Instantly, susceptible as I was by the wood-fire with my wine, I recognized that bird as the spirit of Carpaccio himself, and I heard it calling to me joyously out of the centuries like an old acquaintance. I was elated. In my mind I returned the greeting – *Ciao Carpaccio! Come sta?* – and before I went to bed I resolved to write, purely for my own pleasure, this self-indulgent caprice.

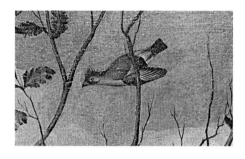

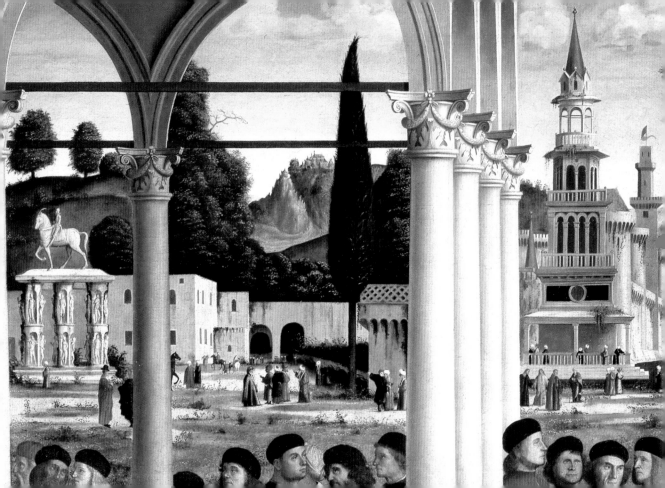

1. Virtual relationship

In 1961 Goya's famous portrait of the Duke of Wellington was stolen from the National Gallery in London, and remained undiscovered for a decade. During its absence the first of the Bond films appeared, and prominently in the home of Dr No, the arch-villain of the piece, Goya's painted Wellington wittily hung. If ever a Carpaccio masterpiece disappears from a gallery somewhere, I advise Interpol to come straight to my house in Llanystumdwy, Wales, where they will find it similarly displayed for me to show off to my neighbours.

But however much I delight in Carpaccio's virtual company, I really know hardly anything about the man, and in this I am not alone. Scores of scholars have written about his work and influence, but his life story remains indistinct. 'Of noble birth and long descent was blithe Carpaccio', proclaimed Haldane Macfall magisterially in his eight-volume *A History of Painting*, 1912, but he did not really know. Vittore is variously supposed to have been born, in 1465, in Venice itself, on the island of Mazzorbo in the Venetian lagoon, or at Capodistria – now Koper in Slovenia, but in his time under Venetian rule. He was the son of a leather merchant, or a

furrier, or perhaps something to do with shipping. They say his family originated somewhere in the Istrian peninsula, itself an opaque sort of place, and the family name was originally Scarpazza, Scarpazo in the Venetian dialect. When Latin forms became all the rage among the literati of Venice, Vittore Latinized his signature indiscriminately as Carpatio, Charpatio, Carpatius, Carpacio, Carpazio, Carpathus or Carpathius (which is how he signed the picture of the young knight). Only after his death did Carpaccio catch on.

Cuisine Carpaccio

I suspect the name is best known nowadays, anyway, for the dish of raw beef slices, with a Dijon mustard sauce, which was devised in 1970 by Giuseppe Cipriani, the owner of Harry's Bar in Venice, to spare a customer gastric problems. He

named it Beef Carpaccio, off the top of his head, because the look of its beef reminded him of Carpaccio's characteristically red pigments. The dish has proliferated nowadays into venison carpaccio, tuna carpaccio, octopus carpaccio, beetroot carpaccio, even elk or kangaroo carpaccio, and the *Oxford English Dictionary* recognizes the word as a noun rather than a name – 'carpaccio: an Italian *hors-d'œuvre*' – rather like a sandwich, a cardigan or a mackintosh.

You can sample the food eponymously all over the world – there are Carpaccio Bars and

Restaurants in Tel Aviv and Stockton-on-Tees, at Miami and Guatemala City and Niagara Falls. Veal carpaccio, I am assured, was once in demand among the dancers of the Folies Bergère in Paris as padding for uncomfortable shoes, while the founder of the well-known Carpaccio Dachsund Kennels, at Swindon in England, tells me that he took the name out of a book, *The Sloane Rover's Handbook: The Chic Guide to Good Life for the 'in' Pooch*, which mentioned the painter and reported that he put dogs into his pictures (though never I think dachsunds).

The look of him?

Vague, then, as Carpaccio's origins are, and comically irrelevant his modern usages, there are hardly any places where I can sense the physical presence of the man – no birthplace, no grave, no historic atelier. There are many buildings extant in Venice that he certainly frequented, and he must have been a familiar figure in the surrounding countryside too, and in the towns of the Venetian lagoon, because he painted many pictures for churches there; but since I don't know what he looked like, I find it hard to summon his form anywhere at all. There is no known portrait of Carpaccio, either, only an alleged self-portrait of dubious authenticity which shows him lightly bearded and wearing what historical sources identify as 'a black cap of Venetian fashion'.

It seems to me very likely, though, that he did slip his own likeness into his paintings. Artists very often did, not least the Venetian masters of his own time. A convenient break in the parade, for instance, allows us to see the face of Gentile Bellini among the spectators at a procession in the Piazza San Marco. Veronese is a showy master of ceremonies in one painting, and plays the viol in another. Tintoretto, in his picture *The Jews Worship the Golden Calf*, is ironically to be seen

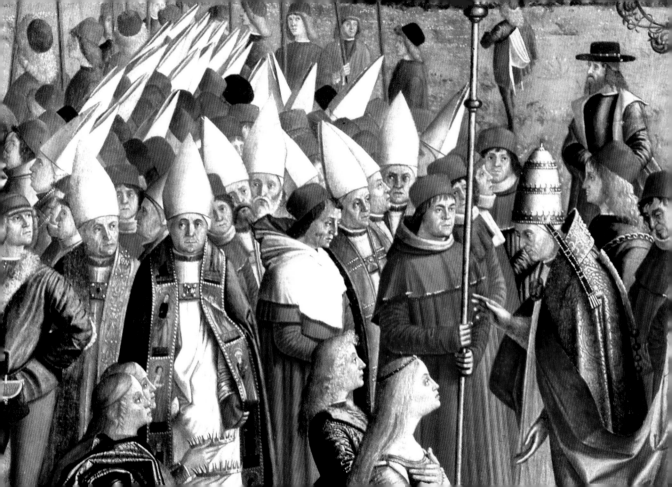

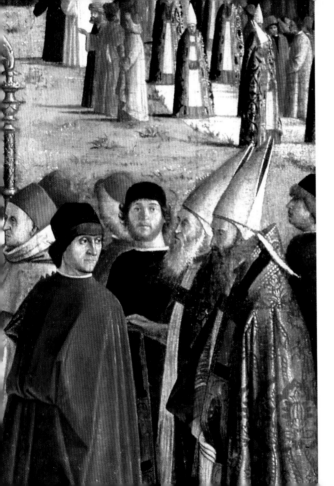

helping to prepare the idol for a ceremony, while his wife looks comfortably on. And some critics maintain that when, at the Hermitage at St Petersburg, Judith contemptuously steps upon the truncated head of Holofernes, she is really treading the face of Giorgione.

So it is no wonder that aficionados of Vittore Carpaccio have assiduously tried to find him self-portrayed in one or another of his paintings, and sometimes believe they have succeeded. As the art historian Terisio Pignatti once put it, occasionally 'in an ambassador or nobleman, in this or that figure who looks out from a crowd or procession, we feel we have encountered the keen or quizzical glance of the artist himself'. Several critics recognize him, unsurprisingly, in a lightly bearded figure wearing that black cap of Venetian fashion. One glimpses him among a crowd of clerics in attendance upon a pope at Rome. Somebody else thinks he may be a sort of youthful Chorus, at the very edge of a narrative

picture concerning St Ursula, whose forefinger is meaningfully pointing towards something or other; but since that something or other was cut from the canvas long ago, we don't even know what he is pointing at, or why.

The most persuasive theorist, to my mind, is the eminent art historian Patricia Fortini Brown, who directs us to one of Carpaccio's lesser-known paintings, the *Disputation of St Stephen*. It shows the young martyr confidently debating with a group of rabbis in a pillared loggia beside a square in Jerusalem. The synagogue scholars are hooded or turbanned, and are supplied with open reference books. A stray pheasant is pottering about. Groups of oriental figures populate the square, and just outside the loggia people are eavesdropping upon the discussion.

Among them, unobtrusively observing the scene around one of the pillars, not quite inside the loggia, is a small solitary figure, lightly bearded and wearing – yes! – a black cap of

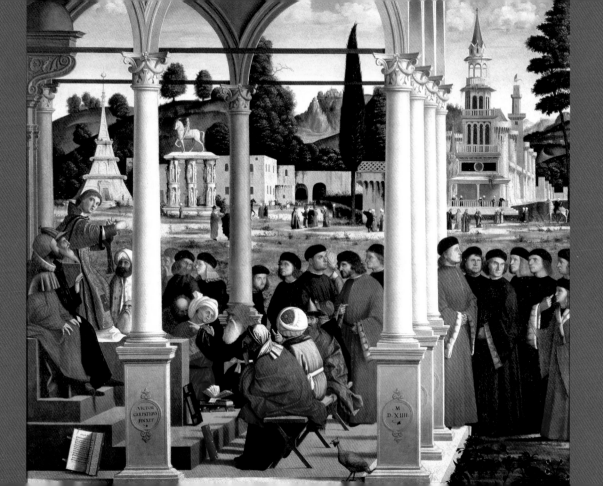

VICTOR
CARPATIVS
FINXIT

M
D. XIIII

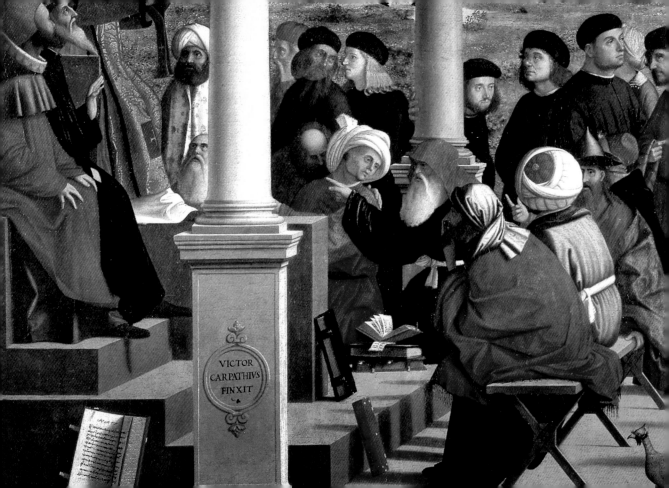

VICTOR
CARPATHIVS
FINXIT

Venetian fashion. He seems to be on his own, separated from the rabbis, not apparently engaged by the fervours of the saint, but Ms Fortini Brown points out that on a pillar plinth almost directly in front of him, from our own viewpoint, are inscribed the words VICTOR CARPATHIUS FINXIT. She thinks the young man does look rather like the sitter in that one debatable portrait, and seems vaguely familiar from other paintings too, and so makes the gentle suggestion ('hypothetical and unprovable') that the watcher on the fringe is Vittore Carpaccio himself.

(But wait – how about that other young man, the one pointing at himself just nearby?)

Like most of the other witnesses Ms. Fortini Brown sees Carpaccio only glancingly, as it were – a bit player in the drama of his art; but in 1907 the scholars Pompeo Molmenti and Gustav Ludwig hypothetically promoted him to a starring role. In Carpaccio's painting of the

martyrdom of St Ursula the saint is murdered by an executioner's arrow, watched by a horde of pagans and presided over by the helmeted King of the Huns, on horseback. Legend had it that the heathen King's own son was in love with the virgin, and sure enough in the centre of the piece is a civilized and elegant young man, apparently sheathing his sword in regret, and reminding me of a matador at the moment of a kill. Could not this handsome youth, ask Molmenti and Ludwig, be that prince, 'gazing with such a lovelorn look of pity upon the maiden'? And, more to our point, might not he be represented, in this climactic scene, by its creator Carpaccio himself?

Well he might, I think, but I am in no position to judge because I myself find, from long immersion in Carpacciana, that I seem to see him everywhere in his pictures – even now, as I turn the well-thumbed pages of my Carpaccio books, time and again I unexpectedly come across him. Like Patricia Fortini Brown, I have no hard evidence to support me. I simply recognize, on and off throughout his œuvre, what I have come to call the Carpaccio Face.

The Carpaccio Face

It is no more than a hint, or a suggestion. It is a curious, quizzical, rather shy, often humorous face that I see, in the person of a soldier, or a young blood, or a saint, or a monk, or a king. It looks back at me in a friendly, conniving way, from quayside or castle rampart, from boat-deck or parade, and sometimes indeed I imagine it transmuted into the presence of an animal - a cocky white dog, or a caparisoned horse chafing against the bit. Very often my Carpaccio Face is the face of a winged cherub, or even the little Christ-Child, and (may I be forgiven) there are times when I have fancied it in the features of Almighty

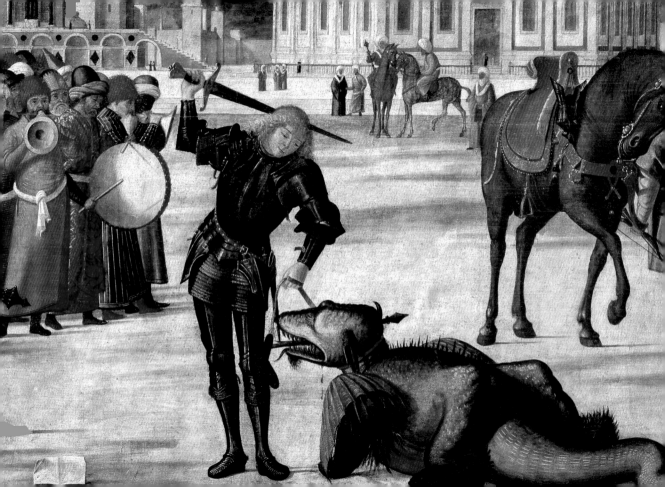

God Himself, surveying His creation benevolently in a Carpaccio altar-piece!

I would be a liar to claim that I have even seen the face in the look of the recumbent dragon about to be finished off by St George in one of Carpaccio's best-known pieces, because I can only see the back of the creature's head. You may remember that it had been terrorizing the mythical Libyan city of Silene by demanding and devouring a daily hostage, to be chosen by lot from the citizenry. As it happened, on the day that St George came riding by it was the princess of the Silenians, beloved daughter of their king and queen, who had drawn the unlucky number. The hero-saint instantly speared the monster, restored the maiden intact to her parents and obligingly killed the dragon after the Silenians agreed to be converted *en masse* to Christianity.

As I say, I never saw the dragon's face in its last moments, but I like to think it looked movingly Carpaccian then, if only because I am so sorry for it. (I am not alone in this weaknesss, either. The formidable Lord Milner, one of the most sternly imperial grandees of the British Empire, was quite touched on the dragon's behalf when he was shown the picture, and I think John Ruskin must have felt the same, because he reported the animal as looking waterlogged.)

A lion's wink

As you see, mine is an eccentrically intimate relationship with Carpaccio, and there is one of his pictures in which I like to think he addresses me almost as an accomplice, slyly, subversively, as he might if we had been summoned together into the presence of some mighty and overbearing authority. The picture was painted in 1516, towards the end of Carpaccio's career. It is a grand formal representation of the supreme

Venetian ikon, the Winged Lion of St Mark. It was done to an official commission from the Republic, and it is still displayed in the Doge's Palace, the very fulcrum of Venetian power down the centuries.

St Mark's association with Venice was old, if shaky. Tradition said that the evangelist had once preached the gospel in the city, and had been told by an angel that his body would one day be laid to rest on an island in the lagoon. In the 9th century a pair of Venetian adventurers stole his corpse from its tomb in Muslim Alexandria and brought it home both to fulfil this prophecy and to serve as a powerful national symbol. With it, as it were, came the Winged Lion immemorially associated with St Mark, and the image of this stylish hybrid became the presiding ikon and banner of Venice throughout the centuries of Venetian power. It was one of the most potent of all national emblems, at once devout and triumphal, beneath which the fleets and armies and merchants of Venice stormed their way to pre-eminence, and it is ubiquitous even now on battlements, castle walls and memorials wherever the Republic ruled.

Actually the lion had succeeded an earlier totem-beast. The city's original patron, the obscure St Theodore of Amasea, was traditionally represented in the company of a dragon he had vanquished, more or less metamorphosed into a crocodile. His image stood on top of a pillar in the Piazzetta San Marco, together with the crocodile, while on another pillar crouched a quadruped of immense age and indeterminate species. When St Mark's association with the city was officially confirmed, Theodore and his crocodile were left undisturbed on their pillar, where they remain to this day (if only in replica), but saintly wings were stuck upon the quadruped; and so a handsome chimera became acknowledged once and for all as the grand mascot of the Most Serene Republic.

By the time Carpaccio came to paint the winged lion, its image and its meaning were deeply ingrained in the consciousness of the Venetian people, and for that matter of the world. It represented God-given power, a mystic Christian voodoo against the threat of Islam. But its genesis, like its anatomy, was by no means straightforward, and Carpaccio doubtless knew it. The creature had first been publicized in the 6th century BC by the prophet Ezekiel, who had seen in a vision four beasts emerging from a whirlwind, one of whom had the body of a lion. It also had four wings, feet like a calf's feet, hands like a man's, the face of a lion seen from one side, the face of a calf seen from the other, and the face of an eagle seen from above. Since its legs sparkled like brass, two of its wings were joined together and Ezekiel did not say what it looked like from behind, it is hardly surprising that, as the 20th-century translator Ronald Knox observed, the whole conception was one of 'considerable confusion'. Nor did St John the Divine make it much clearer in describing, five centuries later, his own revelation of the four beasts on the island of Patmos, because by then the winged lion had six wings.

So Carpaccio did not paint his Winged Lion from scratch. Rumours, legends, dogmas, visions and fantasies attended the image out of the ages. The creature had been portrayed in countless pictures and sculptures in Venice itself, generally holding an open book with the message that the angel was supposed to have conveyed to St Mark from his heavenly master – PAX TIBI MARCE EVANGELISTA MEUS. Four-winged or six-winged, hands like a man's, scrunched up as it was in some semi-heraldic versions, wildly elongated in others, the image of the winged lion must surely have tempted Carpaccio towards satire.

But he was fulfilling an official commission for the Serenissima, he was almost certainly a patriot and he probably needed the cash.

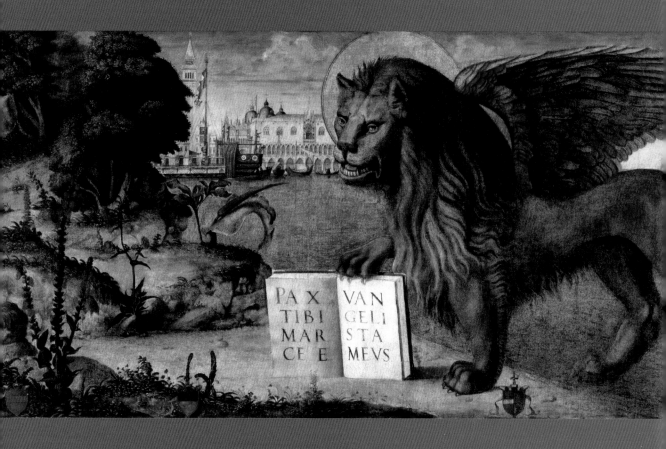

PA X VAN
TIBI GELI
MAR STA
CE E MEVS

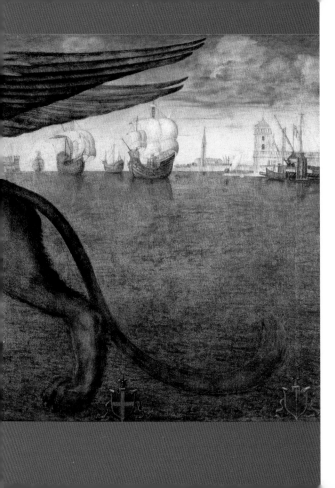

Obvious *lèse majesté* was not a choice. This, then, is how he completed the task in 1516, and how I see it today, as a friend. The picture is oblong, 12 feet long, and commanding. It shows the lion with its back feet paddling in the sea, its front feet on dry land, to symbolize Venetian preeminence in both elements. In one paw the mighty animal holds an open book with God's message to Mark displayed upon it, to demonstrate the city's sacred credentials, and the background of the piece is pure propaganda. Here in distant panorama all the city's greatness is displayed, as Carpaccio's clients required. At one end is the noble ensemble of campanile, domed basilica and Doge's Palace, with a flag on a high mast; at the other end sunlit galleons with billowing sails proclaim Venetian mastery of the seaways.

The winged lion itself, though, dominating the foreground, offers me disparate messages. Its body, indeed, is all the Republic could want: muscular, proud, flaunting its feathered wings

magnificently, with its long tail almost reaching the water behind it, its lordly mane, its pricked ears and its taut hairy belly – what more could a Doge ask for? But the face of the animal speaks to me differently. It is an odd face, set against its saintly halo and looking sidelong out at me. Its eyes seem at once sardonic and a little melancholy. Its forehead is wrinkled. Its mouth could be snarling, but could be smiling. Its teeth look as though they might be false. All in all it is a curiously ambiguous countenance, and its expression strikes me as knowing and slightly impish, as though at any moment the Winged Lion of St Mark might raise one of its three-toed paws along the side of its nose, or wink at me…

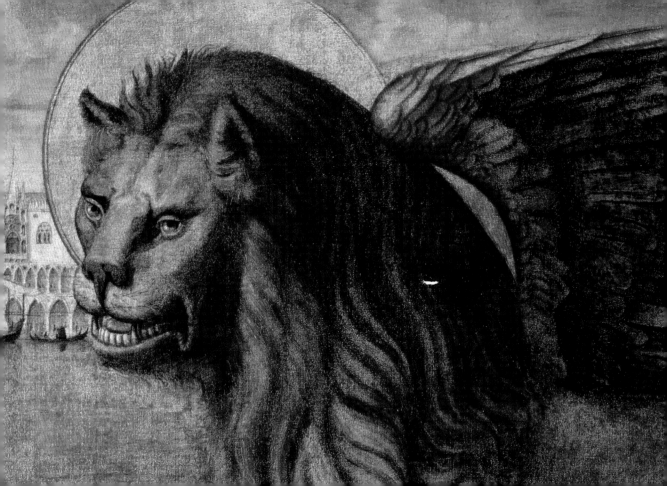

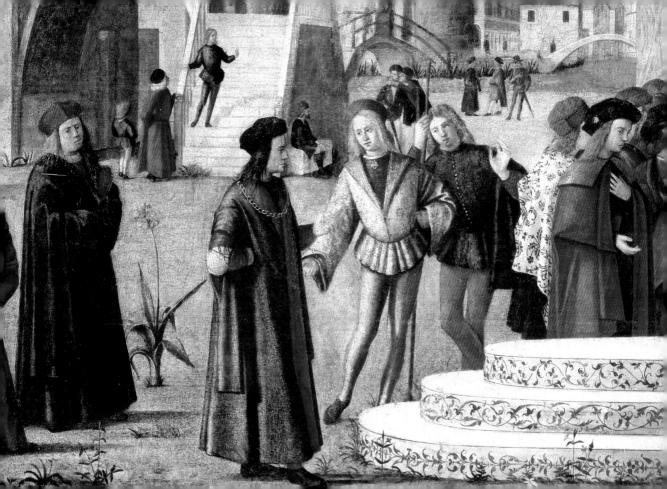

2. First acquaintances

In scholarly circles nowadays the name of Carpaccio chiefly signifies a distinguished practitioner of a particular genre of narrative painting. The genre thrived in Venice in his day. It perhaps had its origins in the mosaics of the Basilica San Marco, which told the Christian stories in a host of glittering designs, and it was fostered by the Venetian *scuole*, religious, charitable and professional guilds of great importance in the social structure of the city. There were five major *scuole*, and at least 200 smaller ones, open to devotees, men and women, from all ranks of society (though some were posher than others). Each was dedicated to a chosen saint, and many of them commissioned artists to commemorate the lives and miracles of their particular holy persons, while dignifying their own premises, honouring Venice and doubtless bolstering their pious self-esteem. As artistic patrons they also had in mind educational purposes, and they sometimes encouraged their artists to include colour, variety, animals and touches of seductive fantasy to add to the popular appeal of their pictures. They also welcomed anachronism, because often living benefactors were portrayed in legendary or historical settings. The result was a distinctive kind of story-telling painting, fundamentally religious of subject but enjoyable too, educational, and grandly decorative.

Most of Carpaccio's principal works were painted for one or another of the *scuole*: a series concerning the legend of the martyred Saint Ursula, for the School of Saint Ursula; a set for the School of St George of the Slavs, commemorating three saints associated with the Venetian territory in Dalmatia (Jerome, George and a mistier divine called Tryphonius); several for the School of St Stephen and one for the School of St John the Evangelist. Some of these picture-narratives owed their plots to the *Golden Legend*, a medieval anthology of saintly biography that was rich in pious invention, and in most of them Vittore deliberately confused past and present, peopling ancient texts with imaginary characters of his own time. The *scuole* perhaps welcomed such historical solecisms because they gave a sort of reality to legendary events and religious traditions, and they certainly add charm to his œuvre five centuries later.

I used to think of these Carpaccio pictures

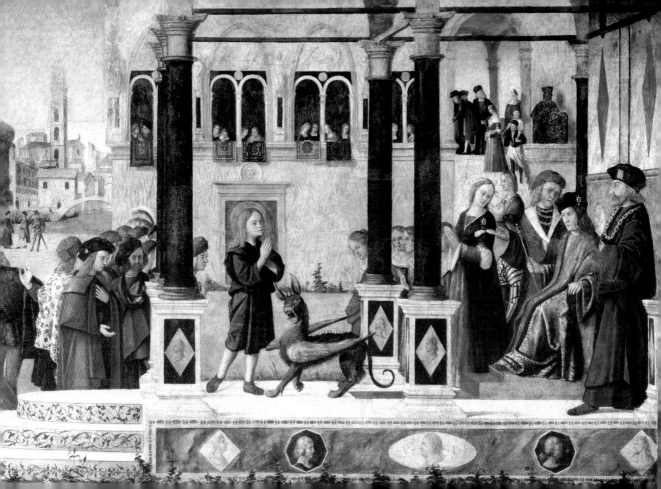

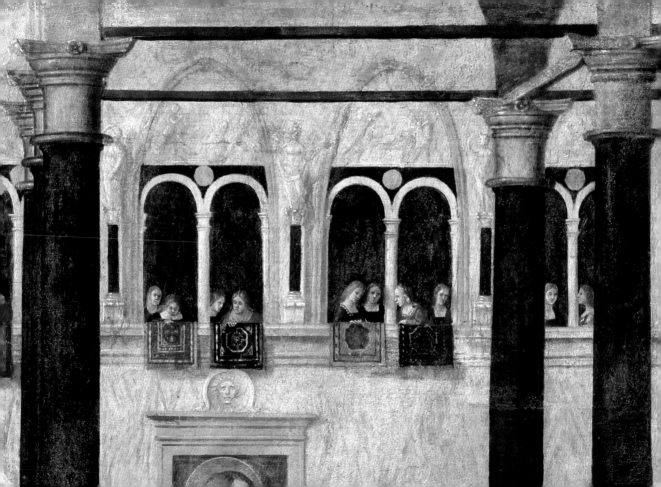

purely as entertainment, if only because some of them remind me of modern graphic novels or comic strips, telling their tales in sequential scenes to be viewed from left to right. They are also so vivid of detail, depicting in exquisite precision so many aspects of life, that visiting them is rather like listening to a lively travel writer, concerned to tell us just what he sees around him, and transport us amusingly to see it too. They are immensely popular to this day, especially among visitors to Venice. They are immediately attractive, often fun, easy to enjoy, apparently easy to understand, not intrusively pious and well-adapted to postcards, souvenir ashtrays and book jackets; and since they were often set against neo-Venetian backgrounds, with Venetian clothes, styles and objects of every kind meticulously reproduced, for years Carpaccio was regarded primarily as a historical memorialist of Venice.

The magic mirror

On one level his work really is the purest kind of reportage. When John Ruskin first encountered Vittore's paintings he defined them as merely 'a kind of magic mirror which flashes back instantly whatever it sees', and so the world has often regarded them. With reason, too. There is an oddly documentary feeling, for instance, to one of his most celebrated pictures, *The Dream of St Ursula*. Hardly more than a child, Ursula was daughter to the Christian King of Brittany, and according to myth her hand was sought in marriage by Prince Conon, son of the heathen King of England – a 'wild and powerful neighbour', according to the *Golden Legend*. She and her father agreed to the proposal, on condition that before the marriage Conon must be converted to Christianity (and re-named Etherius), while Ursula must make a pilgrimage to Rome accompanied by 11,000 attendant virgins.

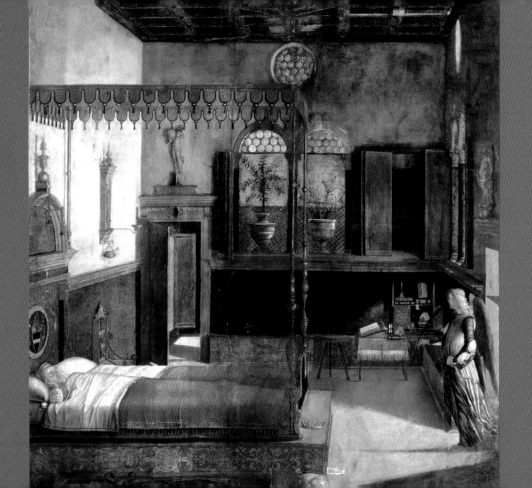

Somewhere in the course of this journey the princess had a dream in which an angel warned her – or promised her, perhaps – that she was soon to be martyred in the Christian cause, and it is this solemn and dramatic moment that Carpaccio chose to portray in the third picture of his St Ursula story cycle.

The picture has been extravagantly admired, but I am not as moved as I should be by its devotional meaning. A small and unobtrusive angel, it is true, stands near the right-hand edge of the painting, holding the palm of martyrdom, but the emphasis is on the bedroom – a respectable young woman's bedroom, in which a respectable young woman is lying asleep cosily tucked up on her half of an otherwise unoccupied double bed. Her lap-dog is snuggled on the bed-side floor. Her slippers are neatly laid out, as they might be in a school dormitory. There is a family crest above her pillow, and her coronet, for she is a princess after all, is at the

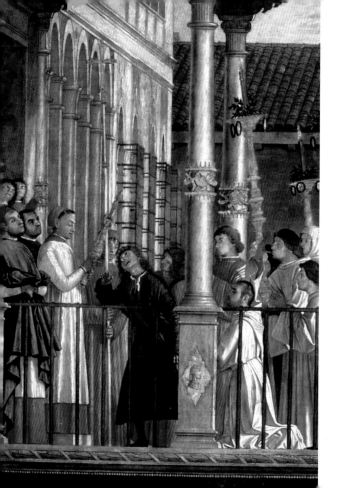

foot of the bed (although it may be a martyr's crown). The bedtime book she has been reading is open on her table, and there are potted plants on the window-sills. Ursula is not woken. The angel does not disturb her, and I tip-toe from the room myself more aware of the décor than the dream...

Another example of this detachment commemorates an exorcism which was supposed to have occurred in Venice during Carpaccio's own lifetime. He recorded the event in an almost matter-of-fact way for the School of St John the Evangelist, whose fragment of the True Cross had miraculously cured a deranged man of his insanity. The miracle part of the picture – the cure of the madman by means of this sacred relic – appears at its top left-hand, almost in brackets as it were, and all the rest is a startlingly vivid depiction of medieval activity around the Rialto Bridge. It reminds me of W. H. Auden's observation about sacred paintings –

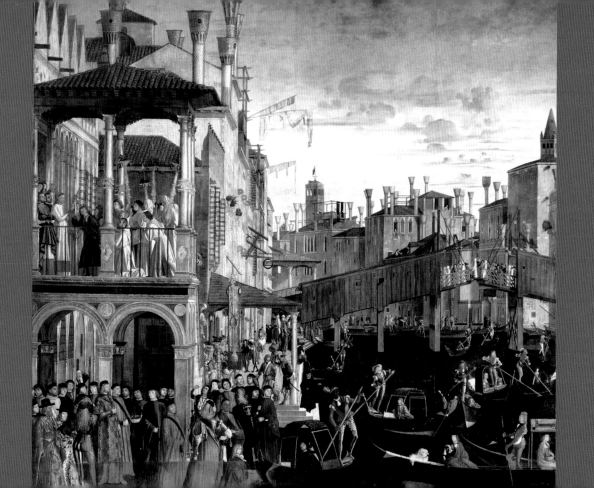

> *For the miraculous birth, there must always be*
> *Children who did not specially want it to happen,*
> * skating*
> *On a pond at the end of the wood.*

There is a particular irony, though, to Carpaccio's *Miracle of the True Cross at Rialto*, because it is universally admired to this day not for its sacred meaning at all, but for its unrivalled documentary value as a record of life in the heart of Venice, *c.* 1500.

Visiting Vittore

Fortunately, since I find it so difficult to conjure the living presence of Carpaccio anywhere, at least in Venice I can immerse myself in his original pictures – not the reproductions that I have at home, but the real things. Examples of his paintings and drawings are scattered, of course,

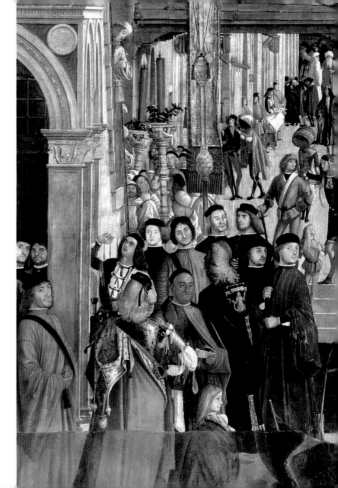

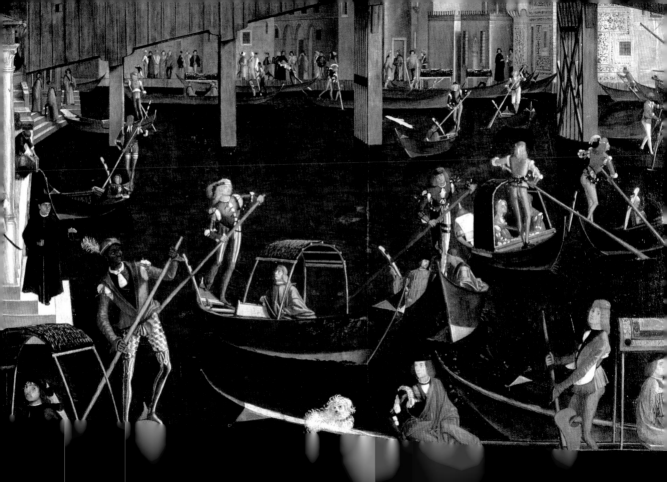

throughout the western world, in galleries and collections from Malibu to the Hermitage, from Stockholm to Belgrade, and including, I am proud to say, my own college of Christ Church, Oxford, England. (Alas, Jan Lauts' standard Carpaccio catalogue listed, in 1962, eleven pages of Rejected Attributions, including one from my *alma mater*.)

But most of Vittore's greatest works are in Venice, the city of their commissioning. Many are in the Accademia art gallery, but many more hang to this day in the very building they were painted for, the Scuola di San Giorgio degli Schiavoni, the School of St George of the Slavs. Visiting them there is the closest one can get to spending time with Vittore, and I will now tell you how to get there. If you leave the Piazza San Marco through the Piazzetta, turn left when you reach the waterfront, cross the next bridge and take the first turning left again. At the T-junction turn right, then take the first left and follow the street until it ends at a canal. Turn left again, and then take the second bridge on the right. When the street divides take the left fork. Follow the street to the end, turn right, turn immediately left over the bridge and the Scuola is on your left.

'By God's sonties', Shakespeare's Old Gobbo exclaimed when told the way to Shylock's house through the Venetian lanes, ''twill be a hard way to find', and by God he was right: but the walk to the School of St George of the Slavs is worth it,

because the little building contains eighteen of Carpaccio's most memorable paintings.

Seductions

It was because of those very paintings that Ruskin found himself seduced by Carpaccio. Like me, at first he was ravished simply by their charm and intricate detailing – he painstakingly copied, in watercolour, one of Carpaccio's chairs. They offered the effect, he wrote then, 'of a soft evening sunshine… or the glow from some embers on some peaceful hearth, cast up into the room where one sits waiting for dear friends, in twilight'. Being new to the artist's work, he had not yet recognized its profounder messages – Carpaccio was, he wrote, 'never to be thought of as a responsible person'. But then being without a computer, Ruskin had never seen that little bird with the inquisitive beak, on its twig above the young knight etc.

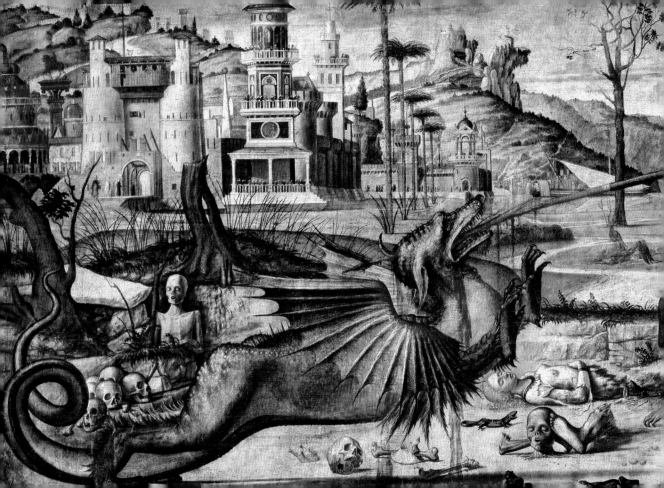

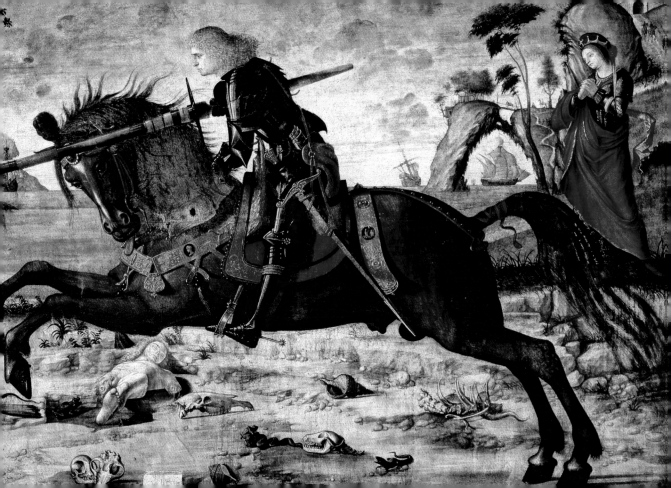

3. Looking for meanings

Even after long immersion in the School of St George I find it difficult to identify meanings for Carpaccio. To my dilettante mind he is certainly not a properly Renaissance painter, his art being short on incensed swirls and splendours, but he is in no way a *naïf*, either, as his mastery of perspective and subtle colouring shows. For years I used to think of him as a Renaissance Innocent, because there is a touch of the child-like to his work, and a particular leaning toward things that children like – animals and birds, fancy clothes, boats and castles, nursery fun and horror stories.

Horror stories?

Yes, but only in religious contexts, and generally, so to speak, peripherally. He did paint one appalling picture of carnage, though, in which the blood-and-guts is central to the theme – *The Martryrdom of the 10,000 at Ararat*. It concerns the 4th century slaughter of a Roman Christian army, on the orders of King Shapu of the Persians, and it really is quite remarkably gruesome. In the year of its painting, 1515, the Venetian Republic was feeling particularly threatened by the Ottoman Empire, so perhaps

Carpaccio felt constrained to depict oriental villainy with extra awfulness.

The slaughter happened on the slopes of Mount Ararat, and the organization of the picture is vertical. At the bottom we see the Christian commander surrendering to the Persians, in an almost festive welter of peculiar headgear, horses, armour-plating and trumpets. In the middle we are shown dreadful things happening to the poor defeated Christians. At the top their souls are seen ascending the mountain, attended by angels, towards a much happier destination in the skies. And all around, right and left, is horror. Tortured or murdered Christians are distributed everywhere, stark naked every one, recumbent or contorted on the ground, twisted high on trees, hanging from branches and all too often crucified in cruel symbolism. It is Grandest Guignol, a far cry from the Carpaccio of Ruskin's magic mirror, and deadly serious.

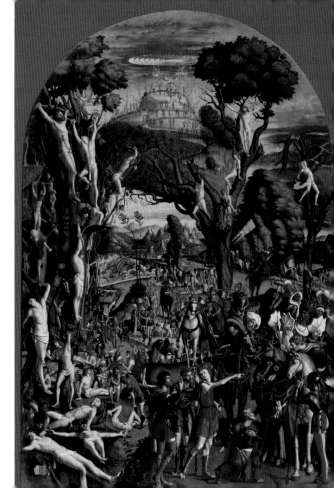

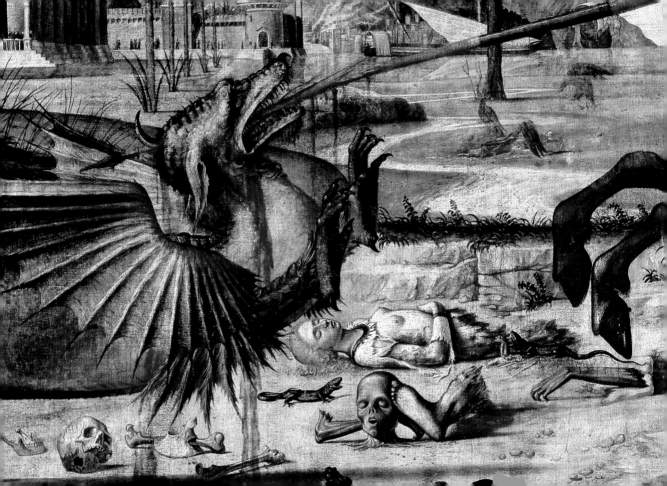

Another of Vittore's pictures is similarly strewn with skeletonic body parts, skulls, thighs and especially jaw-bones (he specialized in jaw-bones), but this one we may legitimately laugh at, without a shudder. It merely commemorates the victims of the dragon that St George slew, and they probably never existed anyway. It is forgiveable to laugh, and they do look a frightful mess, littering the field over which George heroically gallops – like rubbish fallen off the back of a dustbin truck. There are a couple of half-eaten or decomposed corpses, piles of skulls, the odd foot and tibia, the statutory jaw-bone, what I take to be somebody's rib-cage; and crawling and slithering around these macabre mementos are reptilian necrophiles, a snake here, a toad there, horrible gaping lizards. It is enough to satisfy the most *blasé* addict of the genre.

And talking of Carpaccian jawbones, here is my favourite example. It occurs on the edge of a painting concerning the funeral of St Jerome,

53

which hangs with the rest of his Jerome cycle in the School of St George of the Slavs. Centre-stage the old saint lies in death upon his simple paliasse, surrounded by elderly mourning brothers of his monastery, and just visible on the left side of the picture Death himself, in skeleton, presides over a sacred stoup. Even he, though, shows empathetic signs of the ageing process, for his jawbone has fallen off his skull, and seems to be sliding into the holy water.

The menagerie

Enough of the dead! I have a hefty volume at home entitled *Death in Spanish Painting*, an impressive scholarly register that must have taken half a lifetime to write. I would think it much easier (much more fun too) to spend the years compiling a catalogue of Life in Carpaccio's Art, so bursting are his canvases with living creatures

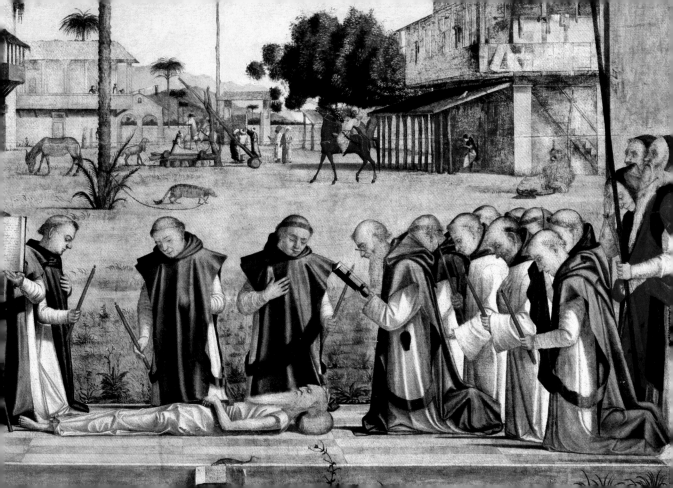

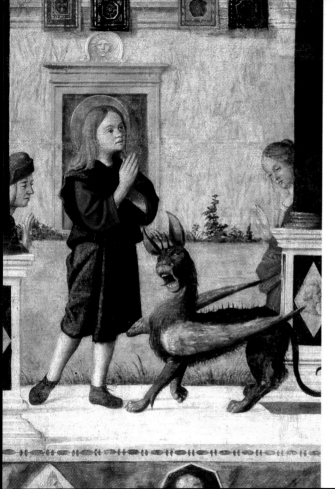

of every style and taste, from an emancipated monkey at the court of the King of England to a tethered hyena at a monastery in Bethlehem. I have counted in his pictures twenty species of animals and at least eleven sorts of birds, plus a unicorn, a winged lion, a basilisk, cherubs, peculiarly multi-antlered stags and sundry angels. They are pictured with anatomical accuracy (although in the case of the angels it is difficult to make out where flesh ends and feathers begin).

Ruskin was particularly taken by Carpaccio's menagerie. He thought one of its birds, a scarlet parrot, might be of an unknown species, and proposed to paint a picture of it in order to 'immortalize Carpaccio's name and mine'. It might be classified as *epops carpaccii*, he suggested – Carpaccio's Hoopoe (better than Elk Carpaccio, anyway). Ruskin was intrigued, too, by a lizard that Carpaccio depicted holding up his own signature in one of his paintings, and he decided to copy it for a zoological class he

was conducting at Oxford. It is a tiny image, at the foot of the picture of Jerome's funeral, and Ruskin had to stand on a borrowed step-ladder stool to do the job properly: but this was 'as bad', he said, 'as drawing it from the life – the thing is so subtle, it is worse than motion.' I can imagine what he meant – like the flicker of a gecko on a tropical ceiling – and I often feel myself that Carpaccio's creatures are actually alive. Remember that bird on the twig, at the start of this enterprise? I swear I heard it chirrup, when I realized its identity.

The Carpaccio Dog

Vittore has been called pantheistic. I am quite sure he revered Nature, anyway, or he could not have painted the birds and beasts as he did. He seems to have loved them in the way Montaigne loved his cat – as equals, unpatronizingly, clear-

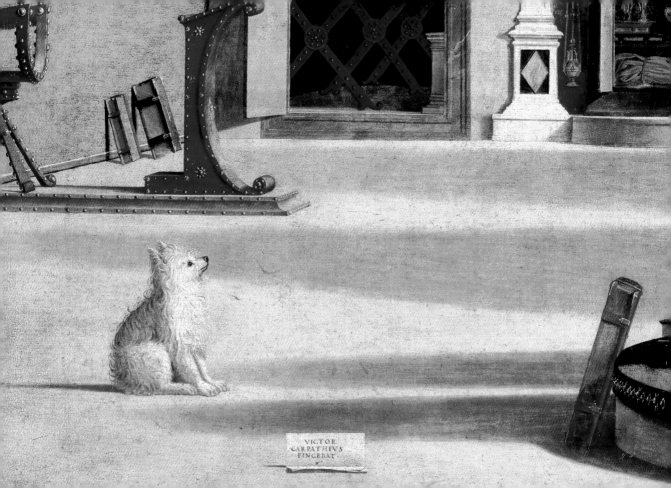

VICTOR
CARPATHIVS
FINGEBAT

eyed, never gushingly. Consider the little dog in his celebrated painting concerning Saints Jerome and Augustine, one of the most famous dogs in all art – the Carpaccio Dog, in fact. Nearly everyone wonders what kind of dog it is. Ruskin, in 1851, thought it was 'exactly like my white Spitz Wisie' (which he described, during a nadir in that animal's career, as being a 'poor little speechless, luckless, wistfully gazing doggie'). Paolo Molmenti (1907) considered it 'a lively little spaniel.' Terisio Pignatti (1958) believed it to be a Maltese puppy, and called its coat 'fluffy'. So did Kenneth Clark (1977) in his book *Animals and Man*. Alberto Manguel, in *A Reader on Reading* (2010), called it simply small, white and shaggy, and I myself (2014), prefer to think of it as a dog of no particular breed, a tough urchin mongrel, cocky, feisty and fun, rescued from the street perhaps by one saint or another, and cherished by multitudes down the centuries. To me it is just The Carpaccio Dog. Doggie indeed! Fluffy my foot!

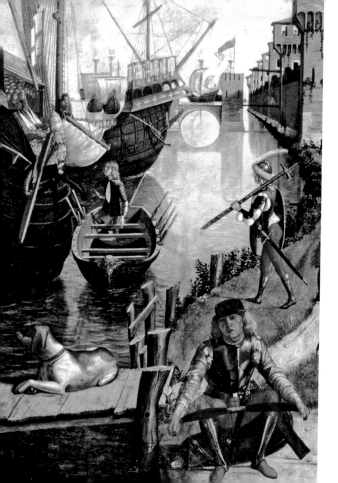

There are many other dogs in the œuvre, not all of them as appealing. There is that sly-faced dog we saw on the first page of this caprice, peering behind the buskins of the *Young Knight*. There is a surly-looking bruiser waiting for St Ursula and her 11,000 virgins to disembark from their ship at Cologne, where they are all about to be murdered by the Huns; the scholars tell me it is sitting next to the scoundrel who will presently kill her – his bow is on his lap already. The white puppy in a gondola beside the Rialto bridge, in *The Miracle of the True Cross*, looks rather namby-pamby to me, while the animal beside St Ursula's bed, when the angel is visiting her in her dream, is unattractively pug-like.

And then there are the disturbing dogs in the foreground of the picture traditionally called *The Two Courtesans*. The two ladies of easy virtue, if such they be, are sitting on their balcony looking extremely bored, waiting for

clients perhaps, and in their listless way they are apparently playing with a couple of dogs. These are not very lovely animals, rather nasty in fact. One seems to be some sort of white hairless terrier; it is sitting on its haunches in a sickly begging attitude at the feet of one of the women, and looking balefully at us with small protruding eyes. She is holding a stick, or perhaps a whip, which is clasped between the bared teeth of the other dog. Only this creature's head shows, at the edge of the picture, and an ugly, half-snarling head it is, while its paw appears to be clamped upon the piece of paper, lying on the floor, which bears Carpaccio's inscription. Neither of the two women are taking any notice of them.

The picture is famously full of enigma, and I don't know what Carpaccio meant those dogs to represent. I only know he didn't much like them. Nor do the courtesans, and nor do I.

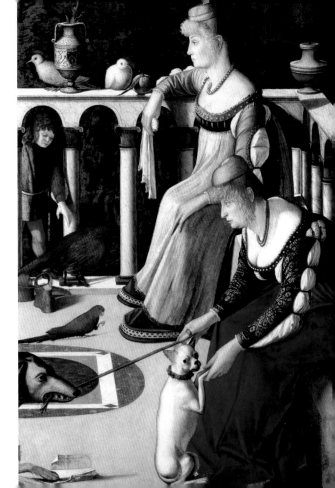

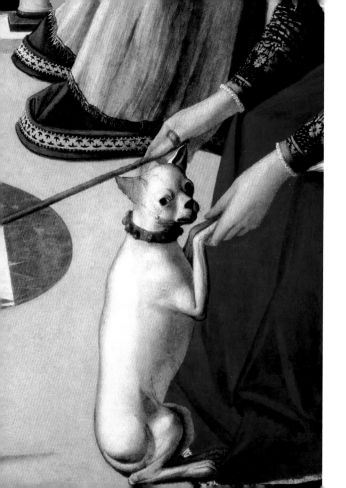

A *thought*

Looking again at that picture, I am struck by the deliberate way in which the terrier is looking so directly at us, as though it has a message in mind, and it occurs to me how often Carpaccio employs this collusive device – as comedians sometimes do.

Often it may be a hint that the character portrayed is Vittore himself, but I recall being looked at in a suggestive way by many and varied characters of Carpaccio's world: off the top of my head a Breton boatman, St John the Evangelist, a Persian chieftain, the man who killed St Ursula, more than one horse, several cherubs and St Jerome.

What are they all saying to me? Is their message always the same?

Leonine

In a preliminary sketch for his picture about Jerome and Augustine the Carpaccio Dog was not a dog at all, but what seems to be a cat, a crouching, weasely thing with a collar around its neck. Having failed so abysmally in this exercise Carpaccio gave up, turned the animal into a dog and, so far as I know, never tried to paint a small feline again.

However he did have a go at the big ones. All Venetians were familiar with leonine imagery, because St Mark's winged variety was everywhere in their city, in architecture as in coinage, on banners and memorials and official documents and trademarks. They were a peculiar lot, even without wings. There were skinny lions and portly lions, elongated lions, lions uncanny and lions absurd, and it seems to me that the only fairly realistic lions to be seen around town in Carpaccio's day must have been three outside

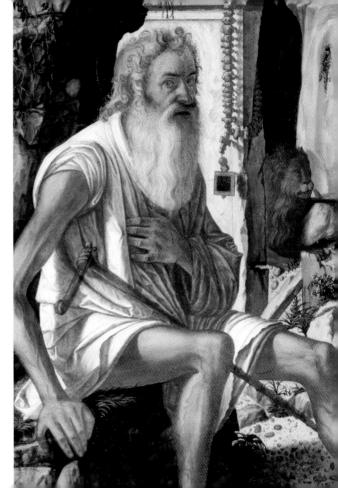

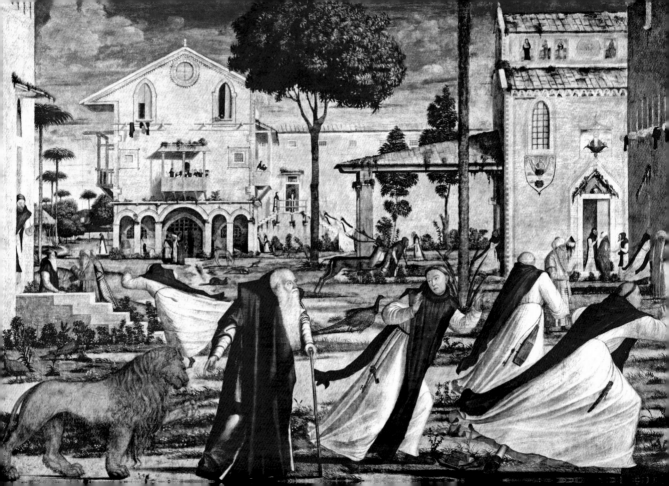

the Arsenal that had been looted from the Ægean and were older than Venice itself. Carpaccio may have been shown other more or less accurate representations from antiquity, or from foreign artists, but I feel sure he never set eyes on a live one himself.

So when lions appear in his own paintings they seldom do so very leoninely (leonically?). The famous lion of St Jerome appears twice in Carpaccio's cycle of pictures about him. First we see the animal soon after Jerome has removed a nasty thorn from its paw, and they have made friends with one another. The saint is leading it into his monastery to introduce it to the rest of the monks, with untoward effect. One and all the brothers are terrified, and flee madly in all directions, leaving the poor lion smiling a slightly embarrassed smile. Next time we find the animal in the background of St Jerome's funeral, and although people sometimes claim to see it looking properly mournful in a distant corner of the yard, it looks to me as though it might be yawning.

All the more remarkable, then, was the winged lion of St Mark that Carpaccio painted almost at the end of his career, the one I fancied winking at me. Disregard my nonsense about it, disregard its wings, consider only its splendid physique, the hair on its belly and its tail of tails. Of all the lions of Venice, chimerical or realistic, down all the ages, it is surely the champion.

Bloodstock

Horses were very Carpaccian. He clearly admired horses, and was familiar with their anatomies. It was not so long, after all, since horses were commonplace in the streets of Venice – today's Cavaletto Hotel, which began life in the 13th century, remembers them still. Their numbers were diminished first because new sumptuary

laws made elaborate harnessing and saddling illegal, and thus reduced the swanky pleasure of ownership. Later they were banned from the Piazza San Marco, and in the end bigger boats on the city canals meant that bridges had to be higher, and stepped, and so made horse traffic impractical.

There were still a very few about in Carpaccio's day, and anyway every Venetian knew a good horse when he saw one because the city possessed five of the most magnificent equestrian statues in the world. Brand-new in 1500 was the final work of Andrea Verrocchio, the colossal equestrian statue of the condottiere Colleoni that stands to this day, marvellously arrogant on its high pedestal outside the church of San Zanipolo. Vittore certainly knew it, because in sublime anachronism he placed it on a still taller pedestal in the background of a picture of St Stephen in Jerusalem. And he was most certainly familiar – who wasn't? – with the four

golden stallions, the iconic Horses of St Mark, which had stood on the façade of the Basilica ever since the Venetians had looted them in Constantinople in 1203. We meet these glorious creatures time and again in Carpaccio's work, portrayed in various guises, numbers, roles and colours, but always with admiration.

Here they stand fastidiously aloof to the slaughter, while all around them the Christians are crucified on Mount Ararat. Here two of them, splendidly caparisoned, impatiently jostle one another while St George delivers the coup de grace to his dragon on the great square of Silene; two more stand ostentatiously ready to take the pagan king and queen of the place to their baptism off-stage (i.e. to the next picture in the cycle). The soldier-saint Vitalis is proudly seated on a white charger above the high altar of his eponymous church in Venice, attended by four more saints, and another showy horse, primped as for dressage, carefully saunters into

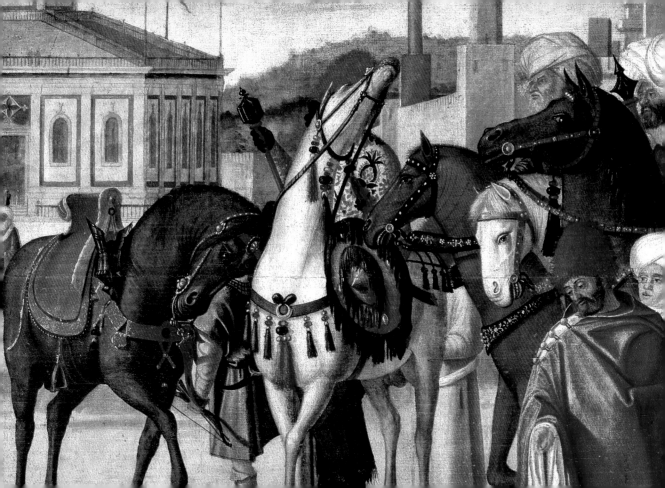

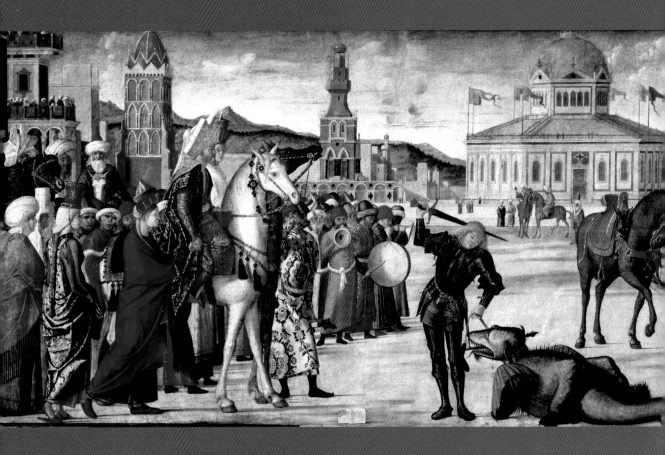

the background of that *Young Warrior* in Madrid. There is a even a model of a horse on a mantelpiece in another of Carpaccio's paintings – even in his time model Golden Horses were desirable souvenirs.

They are all fine, every one of them, perhaps because Carpaccio had modelled them all, if only subconsciously, upon those four glorious studs of Venice. But then he never demeaned an animal. There is nothing freakish to his winged lion of St Mark; as elegant as any Golden Stallion, and as beautifully groomed, is the donkey that conveys the Holy Family to safety in his *Flight into Egypt*…

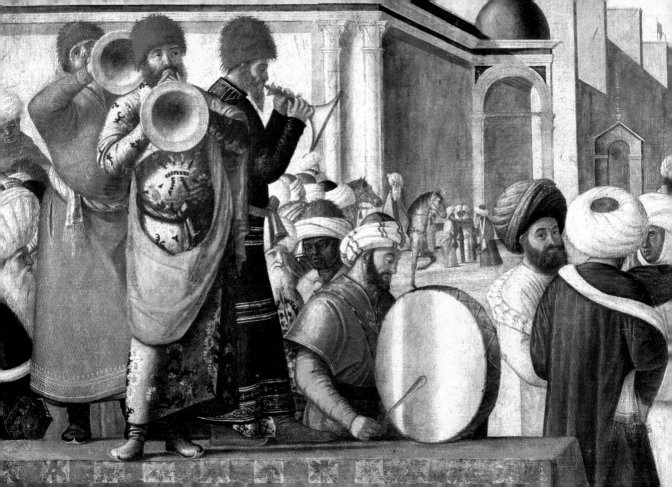

4. Pomp and Circumstance

Carpaccio clearly loved a show, a parade, the colour red and the sound of trumpets. So he was born in the right place at the right time, for at the crux of the 15th and 16th centuries it was generally agreed that nowhere on earth was quite so flamboyantly splendiferous as Venice – 'the most triumphant Citie I ever set eyes on', wrote Philippe de Commynes in 1495. Tapestries, fine liveries, carpets, silks, marbles and porphyries, velvets, pearls, banners and jewels – these were famously the stuffs of Venice then, and Carpaccio made the most of them in his art.

He seems to have been drawn to musicians as heralds of consequence. They turn up all the time, in the most varied of settings, and the gleam and shine of trumpet-bowls is a familiar Carpaccian accessory. I call their instruments trumpets, in a lazy generic sense (and I like the name), but probably they were more often reed-instruments technically defined as 'conically expanding bore-shawms': their music was perhaps more like the music of bagpipes, with some instruments playing melodies, others droning a constant bass, and a drum-beat to complete the ensemble.

Never mind, they look like trumpets to me, and the look of them evidently appealed to

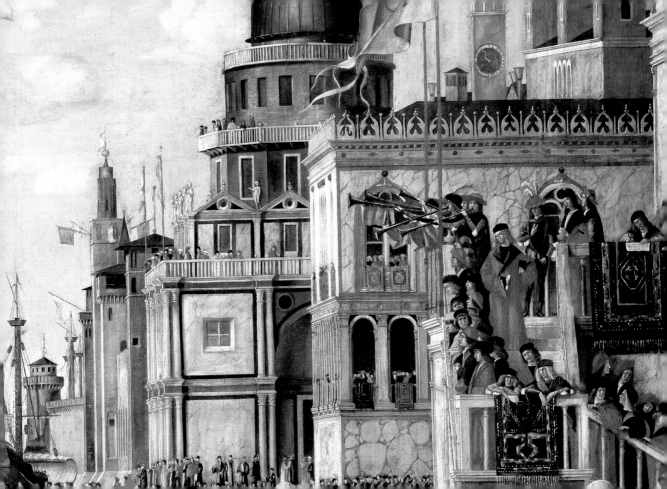

Vittore. How he would have loved the elegant black brass sections of the big band era, leaping in unison to their feet to blast an arpeggio! Here we encounter red-clad Carpaccian trumpeters in close-up, deafeningly near us – three bearded Libyans with a drummer celebrating the baptism of the Silenian monarchs. There they are *en masse*, high on a Breton staircase to bid farewell to St Ursula on her pilgrimage – a cacophony of trumpeters among the fluttering flags. Distant instrumentalists salute the Pope from the ramparts of Sant' Angelo, and a superb young trumpeter holds his long instrument like a weapon in closer attendance upon His Holiness. In the very heart of that appalling maelstrom on Mount Ararat a stylishly mounted orderly blows a command upon his bugle.

But there are less brazen performers too, upon the Carpaccian stage. Diverse charming children play sweet serenades at the feet of the Virgin and her saints. Cherubs bang

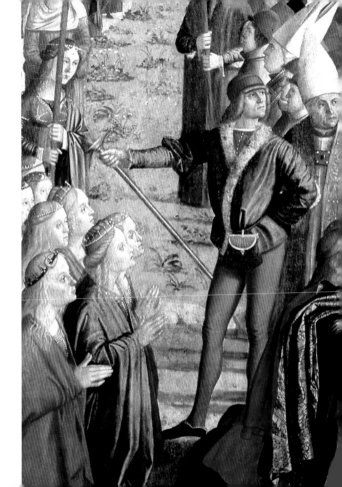

tambourines. When those English ambassadors return from their matrimonial mission to Brittany, an infant fiddler welcomes them home to another quayside with unmistakeable bravado, strutting there like a little prodigy in bright red cap and tunic. And listen! If we linger before Carpaccio's heart-rending picture of the laying-out of Christ, before long we shall hear a thin reedy melody from somewhere; and in the distance we shall see the figure of a shepherd piper, silhouetted on the ridge that connects Golgotha with the hill of Calvary, leaning against a tree and playing his own threnody.

The Carpaccio turban

If the conically expanding bore-shawm was Carpaccio's prime messenger of pomp, his chief emblem of the exotic was the oriental headgear called the turban. This had powerfully

symbolical significance for the Venetians of his time – when in 1571 the galley *Angelo Gabriele* sailed triumphantly into the Basin of St Mark with news of the great Christian victory of Lepanto, trailing in the water from its stern was a huge Turkish flag and a long, long, abject trail of turbans.

Vittore himself was perhaps initiated into its mystique by his acquaintance Gentile Bellini, who painted a portrait of the Sultan Mohammed II wearing a tremendously portentous example, elaborately wound around a red skull-cap. Wherever it appears in his work, even as a white speck in a crowd scene, even among the familiar multitude at the Rialto itself, it reminds us that we are in the presence of foreignness, and probably paganism.

The archetypal Carpaccian turban has been placed on a step at Silene, a few feet away from those bearded trumpeters, while its owner kneels in prayer nearby, having just been

converted to Christianity. For many years I thought it was a small boy with his head in his folded arms, so sympathetically is it painted. It is beautifully laundered, white as snow, and its linen is impeccably wound around its skullcap. Of course its heathen content has been lost, but it is still a very talisman of exotica, and I think of it as the Carpaccio Turban, to be ranked with the Carpaccio Dog.

Many other kinds of turban appear in the œuvre, many of them peculiar, some of them enormous – Ruskin smilingly wrote of one of them that Carpaccio had 'heaped and heaped a snowy crest' upon somebody's head. Often, though, they suggest uneasiness. Turbanned men with uneasy beards stone St Stephen outside Jerusalem. Strangely uneasy turbans are worn at the slaughter on Mount Ararat. Clumps of tur-banned men, in the backgrounds of paintings, sometimes seem to emanate an uneasy sense of conspiracy in the sunniest scenes.

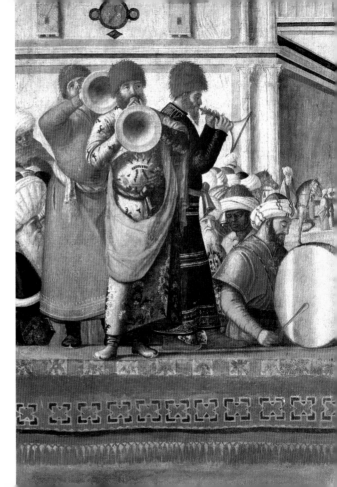

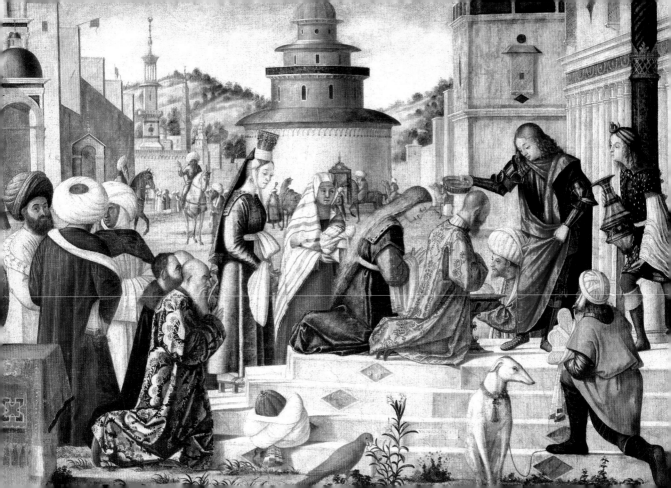

Oddly enough, though, the most disturbing of all Carpaccio's turbanned figures is that of the holy prophet Jeremiah, whose monumental turban is supplemented by a ferociously enormous beard, whose book is evidently open at some especially terrible text, and who is pointing a judgemental forefinger, perhaps, at the godless citizens of Tophet, shortly to be meat for the fowls of heaven and the beasts of the earth.

Hats

Carpaccio clearly liked hats in general, as emblems or tokens. In one picture or another I remember black pointed hats, like wizards', and extraordinary fan-like hats, and cowls, and helmets of course (he liked painting armour) and jaunty feathered hats, and many halos (if they count), and skull-caps, and mitres, and miscellaneous bonnets – also hats like up-turned flower-

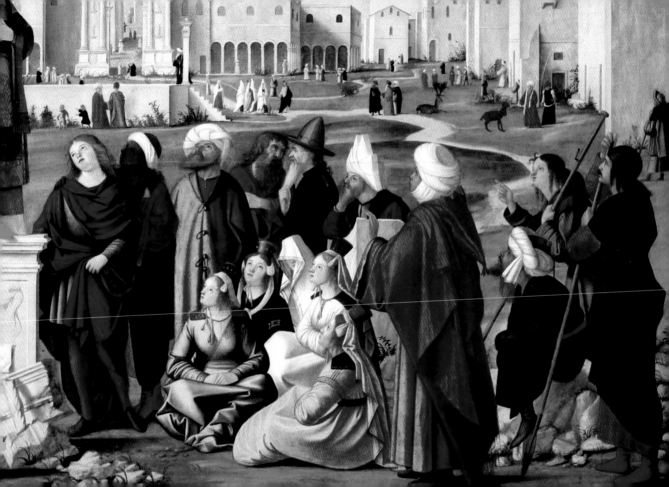

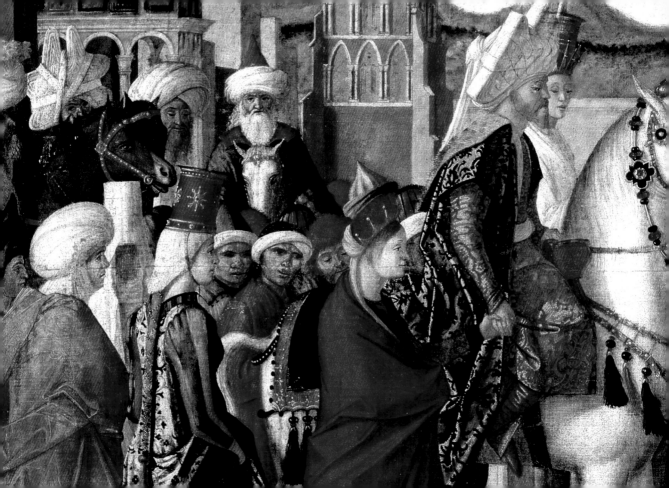

pots, hats like tea-cozies, coronets regal or saintly, papal tiaras, lots of black hats of Venetian fashion and a lady's hat reverentially described by Ruskin as being 'a crimson cap, high, like a castle tower' (he thought the Queen of All the Silenians was wearing it, but it was really only her daughter).

• • • • • •

When I noticed that bird that evening, with the
flash of his colours and his suggestion of gaiety,
even of mischief, I responded at once to the fun
of our contact, and responded with memories of
merriment. I loved recalling those animals and
birds, those comical interludes, the dear old
monks running away through their courtyard,
the young bloods preening themselves on the
quayside, the turbans and the trumpets. But I
knew, of course, that Carpaccio was a man of
more ethereal instinct, too.

• • • • • •

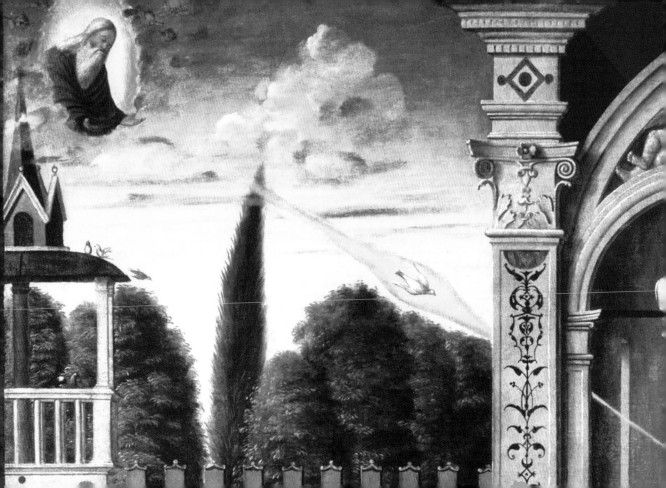

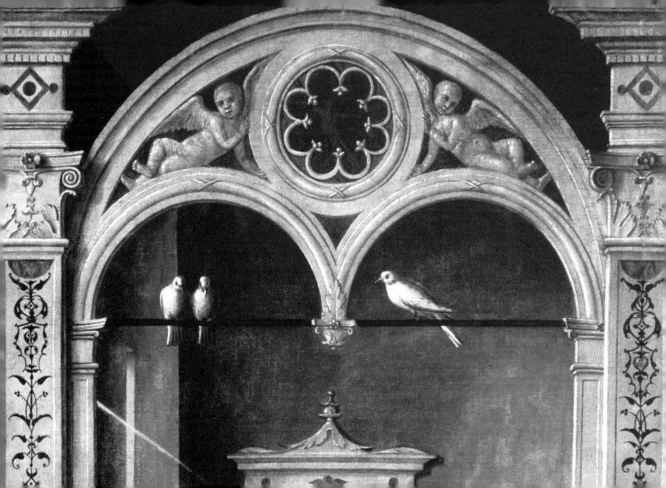

Carpaccio lived in the right place, if it was pomp he wanted, but everywhere in his work he also displays a tender, gentler side. He and his wife Laura had two sons (both of them painters too, though no geniuses), so he knew children well, and delighted in painting them. There is hardly a picture of his without a child in it, or at least a cherub, for his earthly infants elide easily into little celestial beings. Generally speaking both kinds are delightful, and sometimes they steal the scene. That infant Paganini on the English quay catches my eye more easily than the King seated on his throne nearby, and there is a kind of generic Carpaccian six- or seven-year-old – the Carpaccio Urchin! – who plays distractingly around several foregrounds with a dog, a rabbit and, once, a unicorn. Agreeble infants are to be glimpsed leaning over railings as part of the *mise en scène* of ceremonials – they look as though they might have slid down the banisters – and as for the cherubs (some of them black), they swoop and tumble cheekily around the skies of several holy pictures, and sometimes appear simply as airborne baby heads with wings, which makes them look a little like flying footballs.

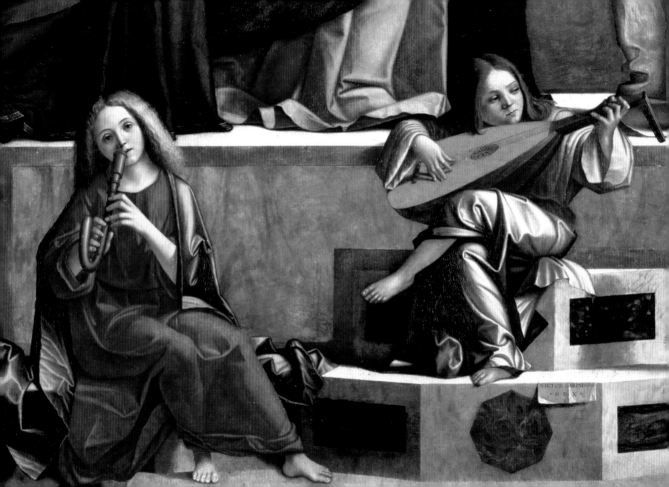

Vittore's Christ-children are not invariably appealing to my eyes – sometimes they are rather plain – but at their best they are lovely, and for me the best of them all appears in a family group, a *sacra conversazione* in the convention known as the Holy Kinship theme. It hangs in the Musée de Petit Palais at Avignon, and it shows the Holy Family set against a richly allegorical landscape of rock and city. Four saints are represented, and two of them are generally identified as Joachim and Anna, the Virgin's parents. They sit on the left side of the picture, and on the right are Joseph and Mary Magdalen, who is there as an honorary member of the family – 'Aunty' Mary, as it were.

None of them seem very cheerful, but anyway the five figures in the centre of the picture are what matters. Two minute putti-musicians are there, trying to entertain the company with a tambourine and a toy lute. The Virgin sits thoughtfully centre-stage, with the naked Christ-child on her lap. And on the floor beside

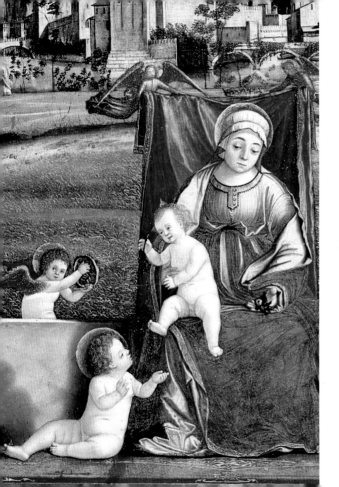

them is another nude human baby, supposedly John the Baptist, who is doing his best to amuse his friend Jesus. They are about the same age, of course, and it is the response he gets from Jesus that most pleases me. Mary looks remote. The rest of the family is unsmiling. But the Lord of All is most happily playing a game with the Baptist. It seems to involve his dropping something into the pudgy outstretched hands of his friend, and although Vittore knows from experience, as well as I do, that the game will presently degenerate into a messy scrabble on the floor, and will very likely end in tears, still that little infant-cameo sets the whole tone of the picture, and cheers us all up.

On *women*

Carpaccio was well-known as a portrait painter of women, and one well-satisfied lady client

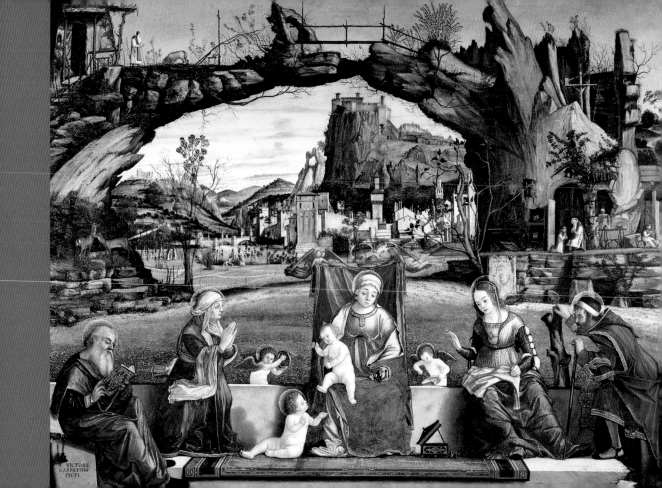

wrote that his 'omnipotent' art could make a living thing out of a piece of wood. To my eyes his portraits of women certainly ring true. However grand they are, they are represented as solid, sensible, capable characters, looking more ready to dispute the price of groceries than to arrange assignations. There is not a Mona Lisa or a Titian Venus among them. Above all the Virgin Mary, who seems to be essentially Vittore's kind of woman, is presented to us as a decent and practical sort of person, not at all the kind to mix with the peacock dandies of his Venice. Carpaccio never completed a picture-sequence about her (though he did begin one), but from his individual paintings strewn around the world I can construct one in my mind, follow Mary's life intimately from girlhood to death, and perhaps learn from the experience more about Carpaccio's relationship with women.

The first picture in my conceptual cycle about her, *The Birth of the Virgin* at Bergamo,

presents her beginnings as thoroughly bourgeois. She is only a few days old in it, and is being bathed by a nursemaid while Anna her mother looks languidly on from her nearby bed, propped up on one elbow. The midwife, I take it, supervises the process from a comfortable carpet seat. Other servants are making themselves useful in the room and in the corridor outside, washing up or preparing sustenance for the young mother, and the Virgin's father Joachim is looking in from the left to see how things are going. What looks like a roll of toilet paper is in the foreground of the picture. The only signs of anything spiritual are a Hebrew text on the wall and, unexpectedly sharing victuals on the polished check-tiled floor, a pair of hungry rabbits.

Soon enough, though, Carpaccio's Virgin has her first experience of the transcendental. When she is still a child we see her, in *The Presentation of the Virgin* at Milan, welcomed into

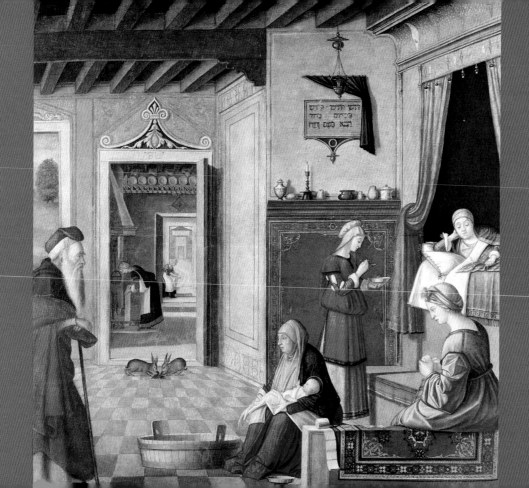

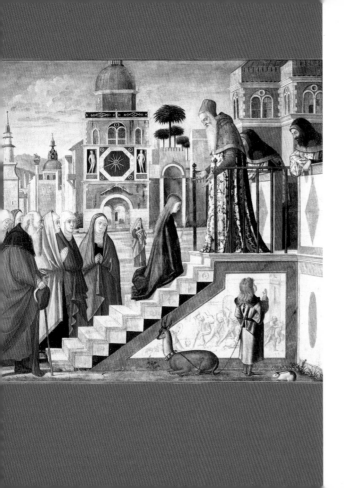

the service of the High Priest at the Temple in Jerusalem. How seriously, how reverently the little girl kneels on the steps of the temple in her long blue robe, blond hair flowing, as the white-bearded old cleric extends his shaky hands to welcome her!

We can stay in Milan to witness Carpaccio's *Marriage of the Virgin*, a very traditional Jewish ceremony, involving the formal participation of disappointed suitors while Mary demurely accepts the blessing of another High Priest: but it is back in Venice, in the Ca' d'Oro, that we are privy, in Carpaccio's *The Annunciation*, to Mary's first revelation that she is to be the Mother of God. With cryptic forefinger raised, the angel, blond, graceful and dramatically winged, gives the young woman the dramatic news; and while she kneels in calm acceptance outside her open bedroom door, a holy dove flies down a ray of sunshine to confirm the news from heaven itself.

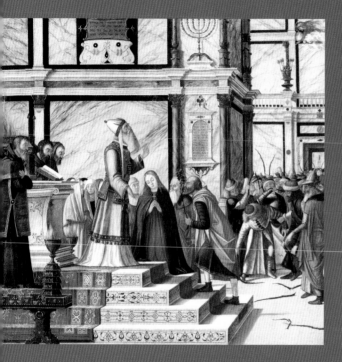
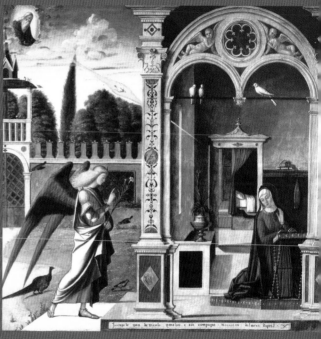

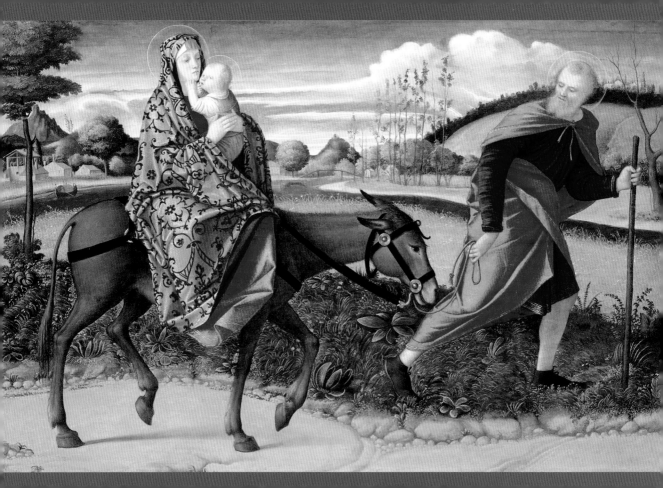

We can go almost anywhere for glimpses of Carpaccio's Madonna in her young maturity, never laughing, seldom even smiling, but always serene, a well-brought-up country girl with her child comfortably in her lap. She looks full of confidence already in *The Flight into Egypt* at Washington DC, steady with her baby on the donkey that is taking them to safety from Herod's murderous intents. Sturdy Joseph leads them, Mary lovingly clasps her child as they jog along, and a snug infant Jesus looks at us with his forefinger knowingly pointing to his mouth. At Washington we see her contentedly reading a book while her baby is distracted by a white rabbit, and another happy example is at Karlsruhe, where in Carpaccio's *Virgin and Child* we shall find Saints Catherine and Jerome come to admire the baby. Mary already looks every inch the practised mother, carefully sustaining the back of her baby's head as the midwife doubtless taught her, and while a venerable Jerome is apparently reading some holy book, Catherine looks as pleased as any other visitor to a maternity ward.

Best of all, perhaps, would be a visit to Avignon, where we can sense for ourselves the developing style of Mary's presence in the Holy Family and Saints that we have already inspected. By now, to my mind, she is becoming symbolical. She sits on her chair as upon a throne, attended not only by family members, but by cherubs too, at the centre of a grand allegorical tableau. She looks no less rural, no less straightforward than she used to. But she is beginning to seem matronly – and sad. She looks tired, too, maybe a little exhausted by her lively baby, and we feel for the first time that perhaps she has some inner intimation of the tragedies to come.

And so we see her when the grand tragedy has struck. Carpaccio has not pictured her at her son's crucifixion, but in Berlin we may see her overcome by sadness in the background of his *Entombment of Christ*, to me one of the greatest of

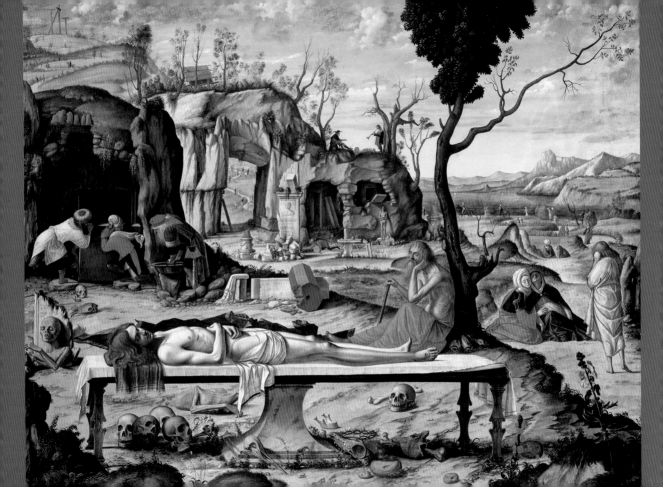

all his works. Jesus lies on a stone slab in the foreground of the picture, while Joseph of Arimathea and a friend prepare his rock tomb in the background and behind them, in a landscape littered with grim symbolisms, Mary lies on the ground in the arms of her friend Mary Magdalene – an old woman now, almost defeated by life, and a very image of Sorrow.

So absolute an image, in fact, that we may not wish to attend her funeral, in Vittore's *Death of the Virgin* at Ferrara. It is a late picture, and rather anti-climactic. Mary now lies perfectly expressionless upon her bier, surrounded by the usual bearded holy men, sages and prophets, and in the sky, above a rather half-hearted Carpaccian cityscape, the risen Christ welcomes her spirit to Heaven, flown all about by those wingèd footballs of cherubim. It is an unworthy conclusion, for throughout this putative cycle we have been following the life of a woman full of strong character, steady, sensible, affectionate, unpretentious, competently maternal – all qualities, I like to think, that Carpaccio must have admired in less celestial womanhood.

Here's a curious afterthought, though. Carpaccio painted two versions of St George's fight with the dragon. In the first the rescued princess watches the fight with elegant composure from a convenient vantage-point. In the second version, painted at least ten years later, she is hiding winsomely behind a tree.

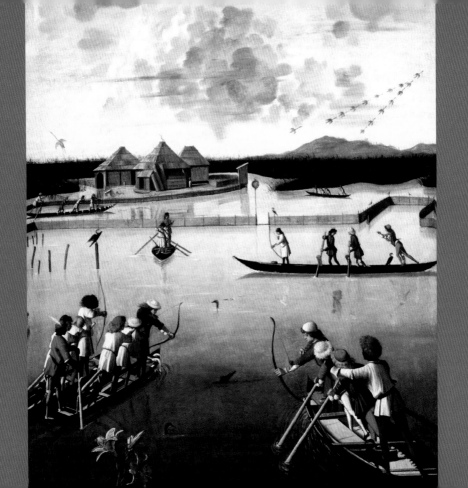

6. Laughter

Among Carpaccio's subtler instruments of art was his ability to be gently funny. His humour is not always obvious - perhaps only I have glimpsed that wink in the eye of the winged lion – but once or twice, it seems to me, a painting of his is frankly meant to make us laugh.

The one traditionally called *Duck Hunt on the Lagoon* makes me laugh, anyway. It shows six boatloads of sportsmen, armed with bows and arrows, swanning around in a backwater of the Venetian lagoon solemnly pointing their arrows at birds that look to me less like ducks than like cormorants, and are now generally called herons.

For the most part the birds seem undisturbed, swimming around with their long-beaked heads protruding from the water, perched on neighbouring posts or, in two impertinent cases, sitting on the sterns of boats while the huntsmen in the bows earnestly take aim in the other direction. In the background fifteen birds of unknown species are flying away in impeccable V-formation, while a sixteenth sits in heraldic attitude on the very pinnacle of a foreshore hut. Perhaps I have failed to grasp the scenario, but I much enjoy the confusion.

And one other Carpaccio scene is frankly farcical. This is the one that depicts St Jerome's

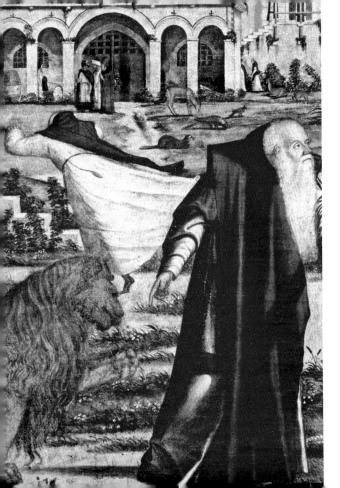

arrival at his monastery in Bethlehem in the company of his lion. The lion is devoted to the saint, and it evidently expects a warm welcome from the other monks of the monastery. It follows Jerome expectantly, almost sheepishly, smiling mildly and holding up its paw as if for inspection. It looks only anxious to please.

But the monks are not welcoming at all. They are terrified, and the picture becomes a comical sort of stage set in which Carpaccio can indulge his fondness for business, in the theatrical sense of the word. The monastery garden teems with business. An ass grazes, a deer leaps, a weasel crouches, rabbits scuttle, a pheasant flutters into flight. Turbanned orientals converse here and there, and a solitary ancient lurches on his crutches towards the monastery chapel. Wildly through it all rush the panic-stricken monks, foreshortened by haste, their black-and-white robes flying, their cell-keys jangling, somebody's breviary dropped on the ground –

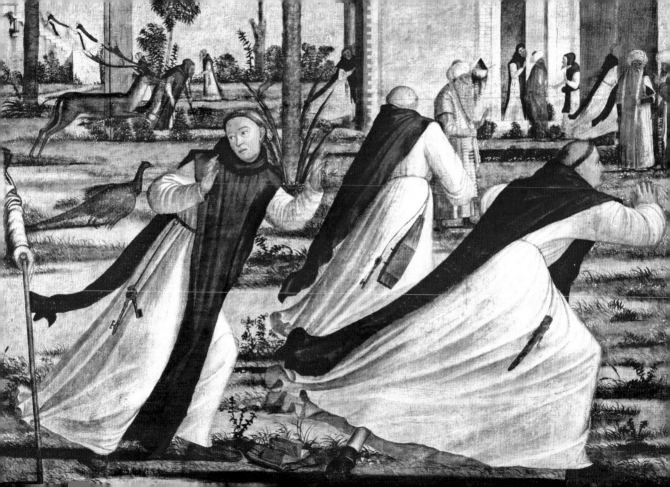

some making headlong for the chapel sanctuary, some rushing two steps at a time up a flight of stairs, others already huddled safely on balconies – anywhere to get away from that dreadful lion, who quietly looks on, still faintly smiling, while dear old Jerome vainly tries to introduce it as a protégé to the community.

Vittore, though, is laughing *with* those monks, rather than *at* them. He has no appetite for the grotesque. He is, I think, sometimes gently amused by the symptoms of old age – arthritic attitudes, spectacled noses - but even his villains are not caricatured. Some of the zealots stoning St Stephen to death outside the gates of Jerusalem actually look regretful, and that man we saw with the bow on his knees, waiting to shoot St Ursula, seems bored rather than villainous.

Swaggerings

Actually the nearest Carpaccio gets to mocking people, the nearest to cartooning, happens when he is depicting Venetians. Generally they are not really Venetians, but he took Venice with him, as it were, wherever his imagination took him – to England, to Brittany, to Palestine or to Libya – and often his characters, whatever their nationality or period, look all too obviously 15th-century Venetian. They gave Carpaccio a chance to exploit his love of contemporary colour and display, and some of his extreme examples of Venetian fashionable swagger really are rather ridiculous.

They often depict members of the *compagnie della calza*, Stocking Clubs, to which the gilded youth of Venice habitually owed allegiance. These were officially sanctioned by the Republic, often took part in State ceremonials to cheer things up, and generally indulged themselves in every kind of high jinks and exhibitionism. They wore gaudy

club costumes with badges on their cloaks or jerkins, and liked, as one might say nowadays, to live it up with showbiz celebs.

Consider one of Vittore's best-known portrait groups, plucked from a crowd scene and frequently reproduced as characteristic of his art. It appears in a painting set in the capital of Brittany, some time in the 4th century AD, in which ambassadors from England petition the Breton king to allow his daughter to marry the son of the king of England. There is nothing remotely Venetian to the story-line, which comes straight from the *Golden Legend*, and the three anonymous figures in the background of the picture play no part in the scene's meaning. They are frequently used, though, to illustrate Carpaccio's mastery of Venetian styles and manners in the early Renaissance.

They are all young men, hardly more than boys, doubtless members of one *compagna* or another, and they appear to be hanging around

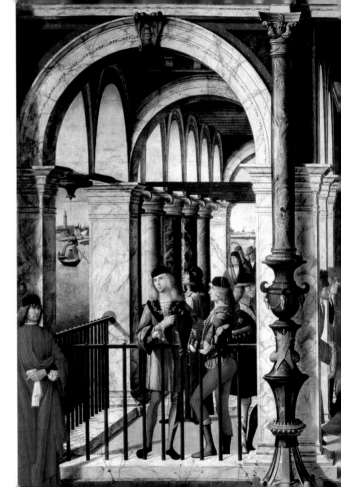

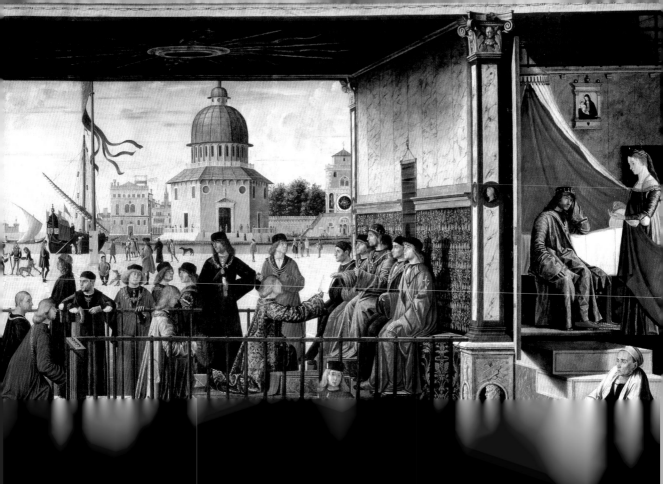

fairly aimlessly on the waterfront of the Breton capital. They are dressed up to the nines, in red and black tights, with scarlet, black and white jerkins, and one holds a boisterous dog on a lead. Two of the youths appear to be doffing their hats to a central figure, with exaggerated gestures of respect, while the third carries a sword, is dressed in elaborate cross-lacing, has a big purse worn as a codpiece, sports a red cap on his blonde hair and is standing there with a stagey air of condescension.

They have come down to us as archetypical characters of Venetian *jeunesse dorée*, slightly ridiculous dandies of Carpaccio's own day, and we tend to forget that they are supposed to be figures in a 4th century townscape. I suspect though, that Carpaccio is mocking them, with their theatrical postures and showy costumes, just as they themselves parody the solemn State occasion that is happening in the foreground of the picture. As the English envoys kneel bareheaded in the presence of the King of the Bretons, so their lordly gestures are mirrored by those young toffs behind them on the quay. They are stifling their giggles, we may assume, probably parodying the comical foreign speech of the ambassadors, and perhaps making a lewd reference or two to the princess's coming betrothal.

Carpaccio was not over-awed by grandeur – elsewhere, depicting a similar assembly of magnificos, he has a cheerful monkey dressed as a senator sitting on the steps outside. He was obviously entertained by the gaudy ostentation of those young bloods on the quay, just as he gloried in the splendour of medieval Venice, whether he interpreted it as historical fiction or reported it as contemporary fact. Historians tell us that in his day the Venetian Republic was relatively unsure of itself, having recently suffered some humiliating reverses in its rivalry with the Turks, but you would not know it from Vittore. His half-fantasy Venice was sumptuously enjoyable, and his fun was always harmless.

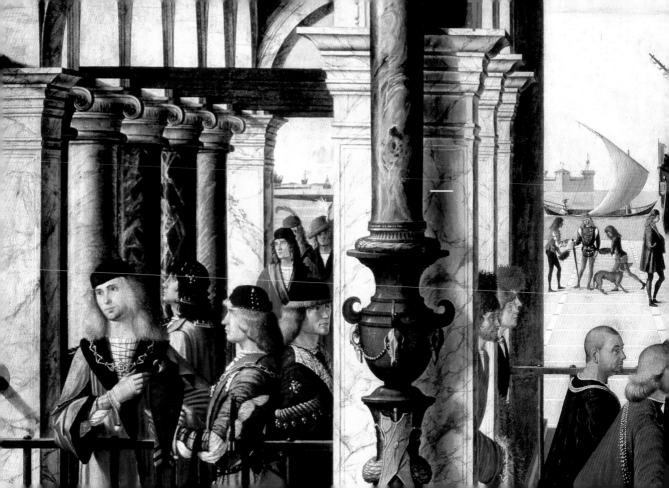

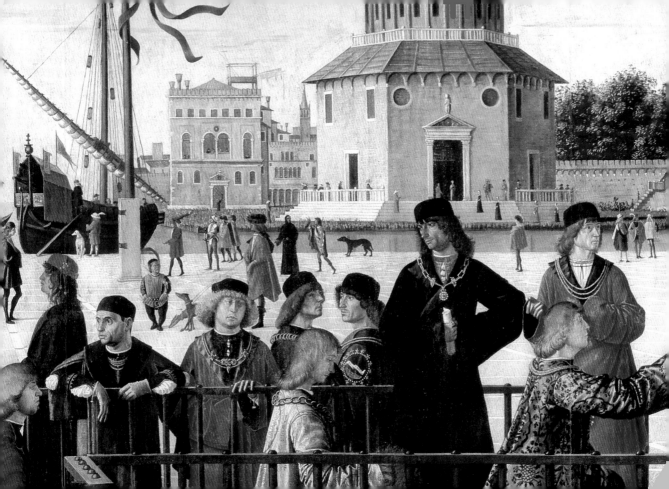

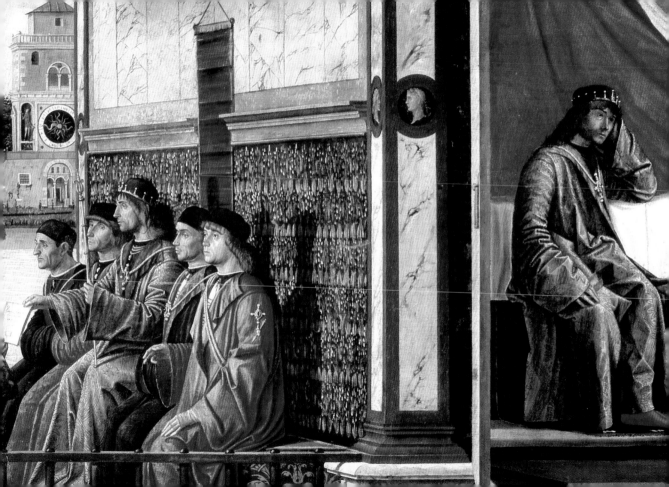

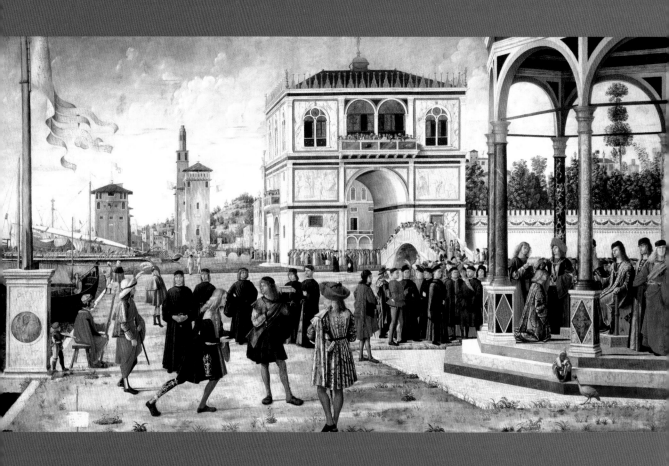

7. Crossing the bridge

My three-year-old granddaughter Begw, having once seen a picture of a building in a Carpaccio painting, instantly went away and drew the building herself, with a big bird thrown in. Perhaps some instinct told her that it was, so to speak, a fairy-tale building, a magic house, fit for a child's fancy.

For immersing oneself in Vittore's work is like crossing a bridge into another sphere. Most of the beings we have been meeting in this essay, all those birds and animals, all those turbanned swells and heraldic youths, inhabit an imaginary place. They play their parts as in a romance, in an invented world – a never-never land, like Oz or Shangri-la – and as often as not we have met them not front-stage, but only in the background of his art.

Of course artists from ancient times rejoiced in painting backgrounds, lyrical mountain scenes, majestic castles, desolate deserts to set hermits against, and it might be said that townscape painting, in particular, was born out of backgrounds. Many a great city or building, sometimes fanciful, sometimes real, is remembered for us because it provides a setting for a battle, a miracle or a legendary encounter.

Carpaccio painted many landscape backgrounds, but for me the fascination of his settings, for all their vivacity, is chiefly technical. Buildings are the thing. Some are real buildings, carefully reproduced, but many more are half-imaginary, in a mixture so esoteric yet so plausible that I venture to call their manner the Carpaccio Style.

Ship-shape

Perhaps this technological instinct had something to do with ships, which meant much to Carpaccio as the son of a sea city. Terisio Pignatti, discussing one of Carpaccio's Ursula cycle pictures, draws our attention to his masterly handling of a fore-shortened iron gate – 'drawn with such precision that its measurements might be worked out mathematically.' It could well serve as a blueprint for a workman, he suggests, but I prefer to think of the Carpaccian taste for technique as being less workmanlike than seamanlike. I remember the suggestion that his family might be in some way connected with the sea, and as a lover of ships myself I relish his apparent obsession with sea-going vessels of all kinds, skiffs to galleons. He painted them so frequently, so enthusiastically and so authentically that the maritime historian Frederic C. Lane was to call him 'the first great marine painter'.

Of course like every Venetian he was immersed from childhood in maritime affairs, and of course too the stories he was told were often concerned with foreign voyagings. So he brings ships into his pictures whenever he reasonably can. They are meticulously drawn, and often appear in books of maritime history as examples of 15th-century construction (for whatever the supposed date and setting of the story he is telling, his vessels are nearly always Venetian craft of his own day).

They are presented with the utmost care, Bristol fashion, however incidental they are to the plot. Here we see, for example, through the pillars of an allegedly English pavilion, a perfect representation of an early Venetian gondola, cited as such in maritime reference books. You almost need a magnifying glass to see it, and it plays no part whatever in the picture's narrative, but there it is in minuscule detail – much smaller than a modern gondola, rowed by one standing oarsman, lacking the distinctive metal prow and fitted with an embroidered canopy beneath which a solitary passenger complacently sits.

Not far away (if only on the jacket of G. B. Rubin de Cervin's standard work on the Venetian navy) we find a detailed illustration of a *brigadino*, one of the smaller galleys by which, in Carpaccio's time, important persons were conveyed at speed to significant engagements – in this case, to bring home the English ambassadors from their matrimonial mission to Brittany.

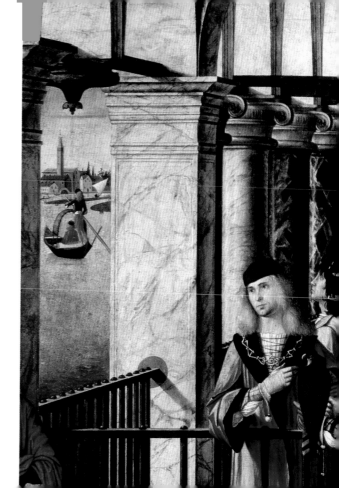

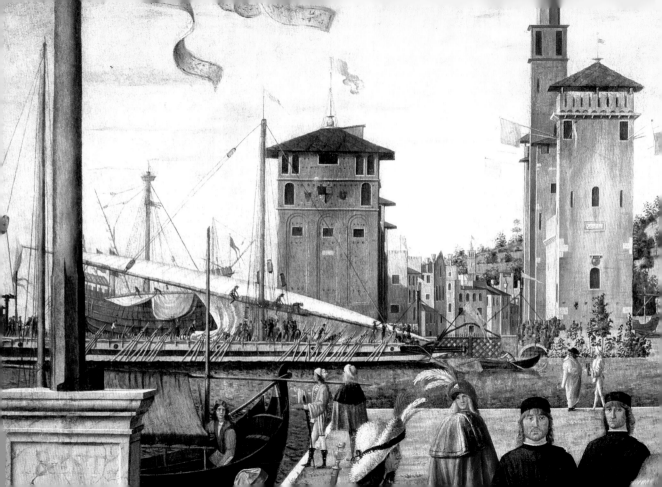

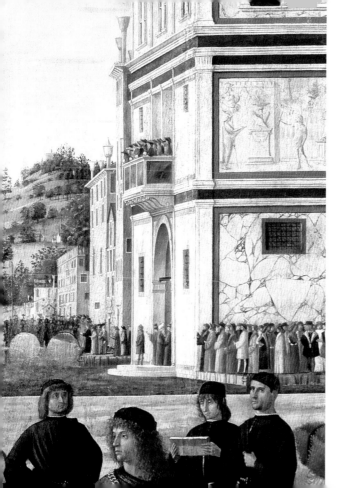

Its crew is swarming all over it, from stern to graceful ram-like prow, and we see how its lateen sails are furled, and its oarsmen marshalled bench by bench. Here and there we find the 'round ships' of the 15th century, hulking vessels with towering 'castles' fore and aft, heavy crow's nests and elaborate riggings, much like the caravels that took Columbus to America during Carpaccio's adolescence. Sometimes a ship is lying off-shore in the background of a landscape, sometimes it is moored alongside a foreign jetty, once it is being careened in an English port. In the background of the Winged Lion picture four ocean-going cogs lie grandly off-shore. And over the haunch of St George's horse, out on the Mediterranean, you may see what looked to me at first sight like a full-rigged North Atlantic clipper, but really seems to be a beautiful sort of oriental hybrid, with two lateen sails aft, an enormous square-sail amidships, two smaller sails forward and a topsail high above the crow's nest

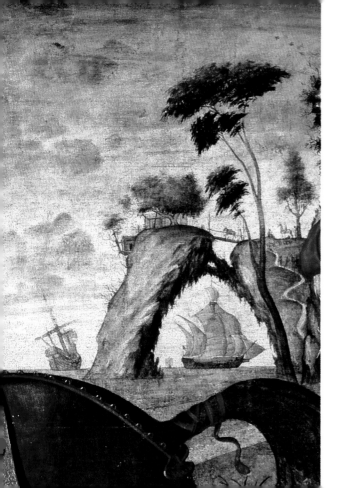

– scudding home from Alexandria perhaps, with luxuries for the Silenian court.

Symptoms of the sea, then, are everywhere in Vittore's work, and time and again we see, behind the main action of a picture, a little thicket of masts and riggings to remind us that, however turbanned the *dramatis personæ* of the scene, however alien the fauna, Venice is not far off, and Venetian ships are there.

By *the way*

Of the multitudinous small Venetian boats that frequent these canvases, one workaday type is especially familiar to me: it is the *sandolo*, and four centuries after Vittore's death I acquired one myself. Also, long ago noticing that a model ship in one Carpaccio painting appeared to be balanced on top of a horizontal beam, rather than hanging from a ceiling, I adopted the system

myself, so that two Venetian fishing craft and three Porthmadog schooners are perched on the oak beams above me as I write.

On bridges

Marcel Proust perceptively observed that Carpaccian ships were 'built up like architecture ... like lesser Venices', and I can easily imagine Vittore's interests gravitating from the ship to another of mankind's original products of technique, the bridge. Great artists often loved bridges, both for their forms, I suppose, and for their symbolisms. Da Vinci not only placed one behind the left ear of the Mona Lisa, but in 1502 actually designed one for the Sultan of Turkey. It never did go up across the Bosphorus, but 400 years later it was built in miniature replica in Norway, a thing of astonishing beauty and technical virtuosity. I walked over it once, as in a dream. It seemed to

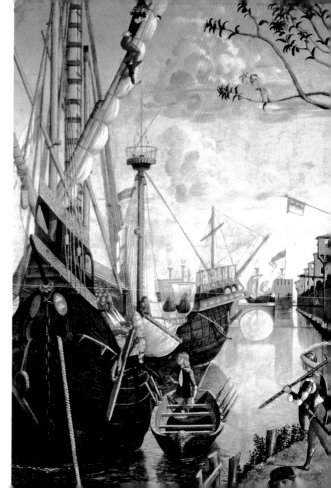

me the very essence of bridgeness, and I am sure Carpaccio would have marvelled at it too, for the engineering of it and for the symbolism.

As it happened, just when Leonardo was sketching his design for the Sultan, Vittore was portraying the Rialto Bridge in Venice, with emphasis on its technique. In those days it was the only bridge over the Grand Canal, and it provides a focus for *The Miracle of the True Cross at Rialto*. Carpaccio looked at bridges with the eye of a constructor, and his depiction of the Rialto bridge is of classic importance because in the following century it was to be replaced. His painting is rather like a detailed technical report on the structure, and this is how I interpret it:

It is a pedestrian drawbridge, with a central span that divides in half and opens upwards: this is partly to let tall ships through, but perhaps because the two irreconcilable clans of medieval Venice are based on opposite sides of the canal, and sometimes have to be kept apart. The bridge

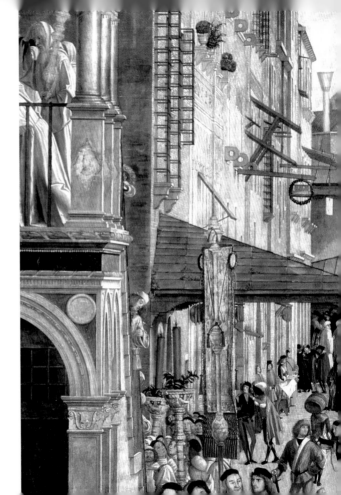

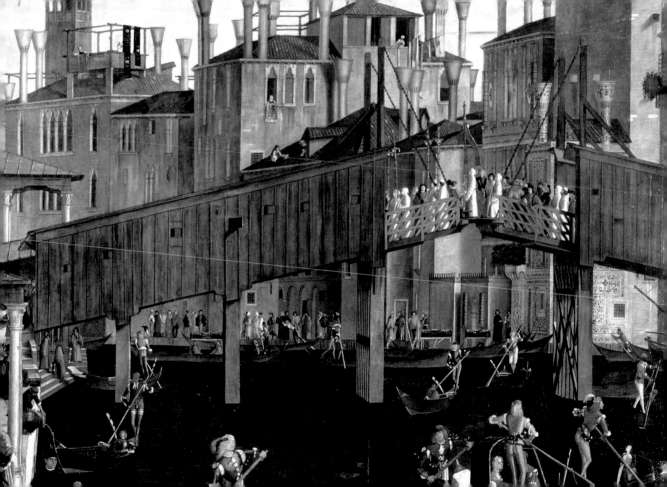

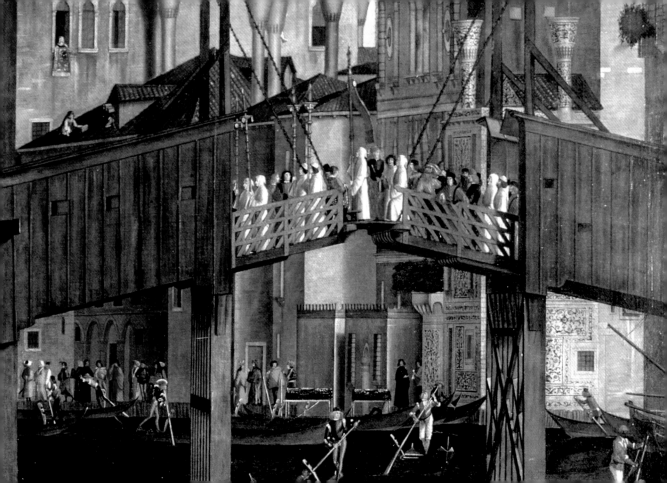

is about 94 feet long from end to end, gently rising towards the drawbridge segment, and its centre is perhaps 12 feet above the water. It is built entirely of wood, sustained by six uprights each made of eight tightly compressed poles, the two central uprights, supporting the drawbridge, being strengthened by diagonal timbers. Except for the drawbridge gap, which has elegantly crisscrossed hand-rails, the bridge is enclosed for its whole length by planked structures containing stalls or shops, on each side of a central walkway. One can count seven small square windows on the visible parts of the bridge, which perhaps indicates 28 shops in all, and at the east end of it, the only one we can see, steps to the left lead on to the canal-bank pavement. The central drawbridge, which is closed in the picture, is opened by chains hanging from iron stanchions, two on each side; pedestrians are crossing it side by side, which perhaps makes it about six feet wide.

The bridge was the fourth on the site. The first one was a pontoon affair, lost to history. The second was burnt in 1310, the third collapsed in 1444, and when the fourth went up later in the 15th century Vittore perhaps watched its construction. He was always good on bridges, and he depicted all sorts – arched stone bridges, suspension bridges, foot-bridges, a dizzily precarious little bridge over a ravine, with a horseman crossing it, in the background of St George's battle-field.

The portal

When it came to the symbolism of the bridge, though, I think he expressed it best in fantasy, in that picture of the Holy Family where the baby Jesus cheered us up.

The family occupies the foreground of the picture, and some way behind them the whole scene is crossed and dominated by a high, wild and massive rocky bridge. It is roughly the shape

of the Rialto bridge, with an incipient gap in the centre where a drawbridge might be, but which is in fact crossed by a simple plank with a hand-rail. The bridge is not unoccupied. Two deer stand in its shade, and in caves and crevices here and there one gets glimpses of hermit-like holy persons, said by the experts to be eminent monastics. One vestmented figure (Augustine perhaps) is taking the confession of a kneeling repentant, and another (Jerome, evidently) emerges from his hut to feed the lion that is crouching gratefully before him. At one end of the bridge is a very well-carpentered cross half-hidden by boulders; at the other end one deer seems to be tenderly licking another.

This bridge is really a portal – bridgeness in a different sense from Leonardo's. I see it as an invitation, set up and tended by men of God, blessed by the Holy Family in front of it, and offering all of us an opening, by way of godly devotion, to paradise behind. For if the family

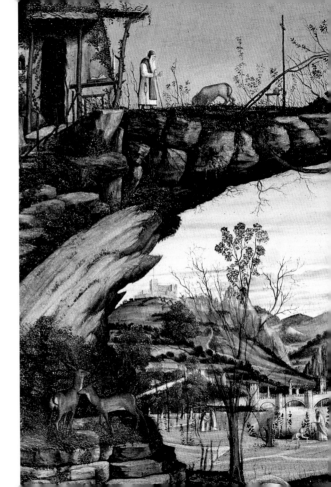

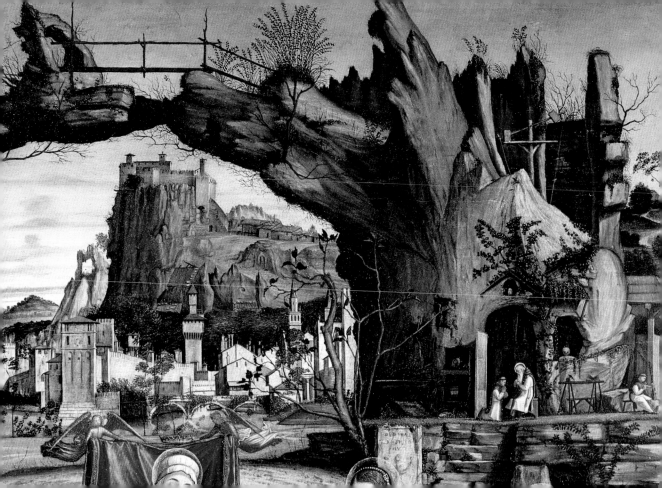

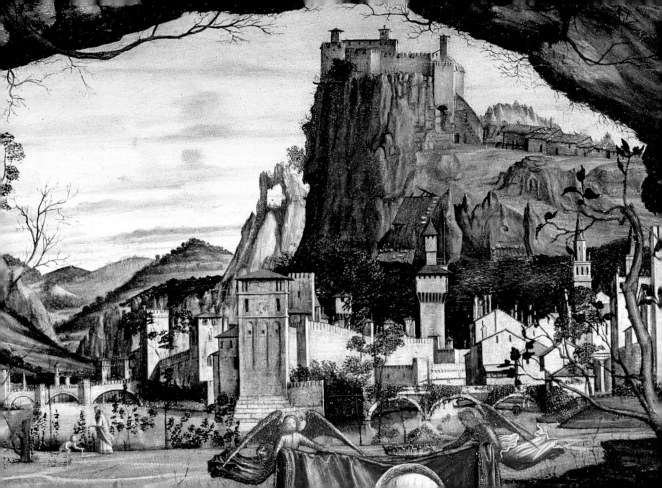

itself is sitting in comparative shade, on the other side of the bridge the land is bright. There, basking in a river valley, gently sunlit, is the most Carpaccian of cities. There is a cluster of towers and a city wall, several steeples of indeterminate denomination, a fine three-arched bridge of course, a well-wooded hill with the statutory path going up it, and two protective castles, one on each side of the valley. Few people are around, and a sense of contented calm seems to pervade the scene, but down by the river a strange little tableau is being enacted. A kindly citizen is doing something good to an unexpected visitor. Naked and halo'd like John the Baptist front of stage, crouched in gratitude in rather the same posture as the dog on the bridge, is a small and unidentifiable little being, ageless, featureless, sexless, faceless. Is it us? Is it a pantheist's self-portrait, after all? I wonder, could it have a message for me?

In 2013 I made a pilgrimage to Avignon to look at the original picture in close-up, in the hope of finding an answer to this conundrum. I came home none the wiser, but a week or two later I was walking along the Welsh waterfront at home when I saw at the edge of the receding tide those very same half-spectral figures, paused for a moment in the very same attitudes. One was actually a young mother, thoughtfully attending to the naked infant playing on all fours in the water at her feet, but believe me for an instant they were in truth those mystical bystanders of the Holy Family.

I am almost sure I could hear the baby's chuckle, and perhaps that was the picture's message after all.

The Carpaccio style

Signor Pignatti, the critic who emphasized Carpaccio's technical craftsmanship, went on to

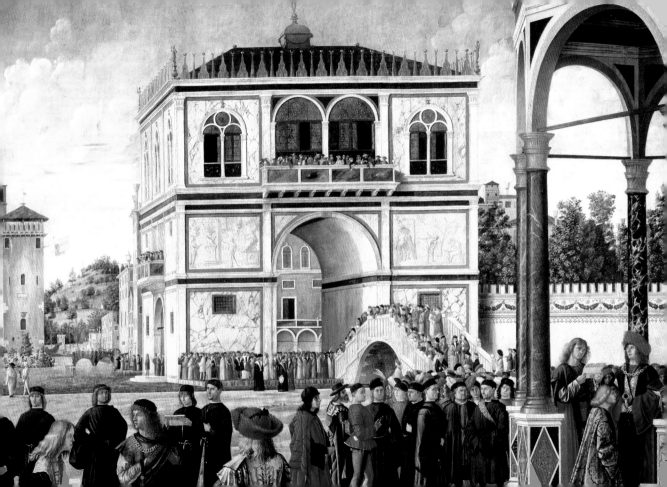

say that he could well have been a professional architect. He loved drawing buildings, and some features of his imaginary structures are indeed truly original. Growing up as he did in one of the world's most beautiful cities, with an eye wonderfully receptive to shape and colour, contrast and balance, it is not surprising that buildings should figure so importantly in his work – and not surprising either that since he was not, it seems, widely travelled, those buildings should be essentially fictional. He did not really know what Jerusalem, or England, or Silene, or Brittany looked like, so he made them up, and crossing the bridge once more from reality to fancy, came to evolve an architectural manner of his own – the Carpaccio Style!

A good deal of it is quasi-Venetian, heavily influenced by the structures of the architect Mauro Codussi which were going up in Venice at that time, changing the face of the city with powerful hints of Byzantium and the classical past. Both Carpaccio's England of Prince Ethereus and his Brittany of Saint Ursula are very Codussian, and here and there in his work are glimpses of contemporary Grand Canal-type palaces and gardens. Sometimes Carpaccio's ideas were actually ahead of his time – a design of fenestration, for instance which appeared in one of his pictures before it ever materialized, or the great dome which went up in his virtual Venice long before Longhena built the Salute at the head of the Grand Canal. His townscapes can be ideologically significant, too. The pagan England of his Ursula cycle is almost sinister in its grim strength (not a church in town), and some of his powerful fortress-buildings are remarkably like the indestructible flak-towers of wartime Berlin.

Much of the style is neo-Oriental, if only because so many of the tales Carpaccio was illustrating were set in countries of the east – he has been called the first Orientalist painter. It is

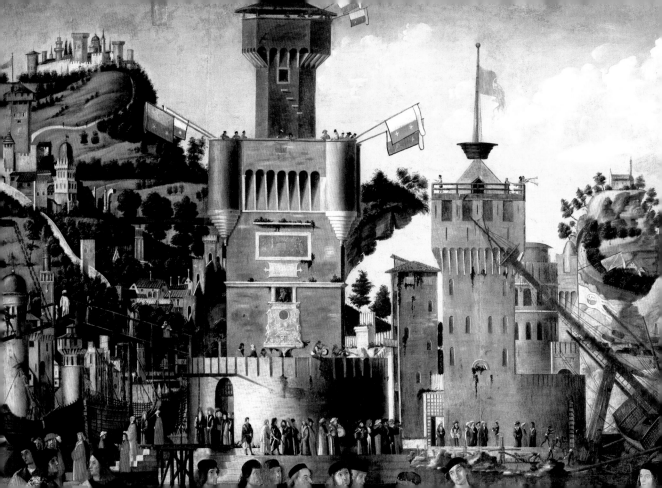

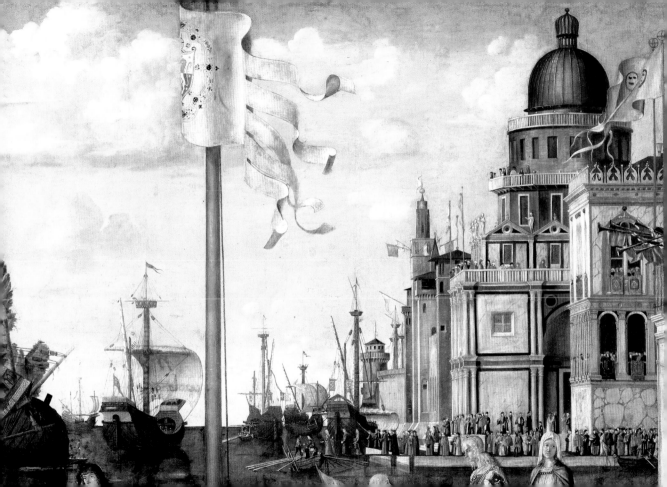

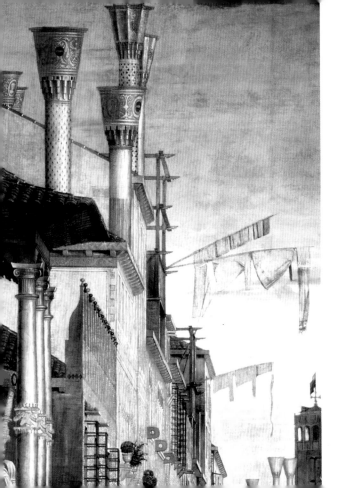

sometimes postulated that he must himself have travelled in the Orient, to have learnt so much about its architecture. Who knows? He had certainly met people who had visited those parts, not least his near contemporary Gentile Bellini, who had spent time on a sort of cultural mission to Constantinople – and it is just possible, in fact, that Vittore was one of the two assistants who went there with him. Most experts seem to agree, though, that some of Carpaccio's architectural details were cribbed from the work of earlier travellers, notably the German Bernhard von Breydenbach, because his background pictures of real buildings in Jerusalem are evidently adapted from von Breydenbach's woodcuts. (Carpaccio also seems to have painted a fuller landscape of Jerusalem: in the one existing record of his commercial methods we are told that in 1511 he offered the Marquis of Mantua a picture of Jerusalem that was, though he said it himself, unique in its size, excellence and

complete perfection. Apparently the Marquis was not persuaded – the picture is unknown.)

But actually the Carpaccio Style is a happy mish-mash, its inspirations eclectic but nearly always entertaining and its examples more or less disposable, since he often used them several times over. Very seldom did Carpaccio frankly portray the contemporary look of Venice. Once or twice, as convention demanded, he included a small lagoon scene over the shoulder of a sitter. He painted the Serenissima with ceremonial accuracy in that picture of the winged lion. There is that duck-hunt. And of course his portrayal of the Rialto scene in *The Miracle of the Relic of the True Cross* is pure documentary, recording not only the bustling life of the city, but the exact shapes of chimney-pots, the inn-sign of the Sturgeon pub and the particulars of houses along the banks of the canal – roughly confirmed by a definitive map of the city drawn by Jacopo de' Barbari at almost the same time.

Much more of it, though, is fantasy. Renaissance painters, of course, often showed made-up towns and castles in the backgrounds of their pictures, but few painted them with such architectural finesse, and one of the great pleasures of spending time with Carpaccio, and getting to know his meanings, is to wander with him through his own imagined city, scattered as it is throughout his work.

Peregrination

Such curious marvels are there! There are countless minarets of intricate pattern, balcony above balcony, surmounted high above the rooftops by the crescent moon symbols of Islam! There are elaborate arcades and pavilions and obelisks and ceremonial arches! There are mighty fortifications! Here, high above conceptual Jerusalem, is a church of the Holy Sepulchre, and below it a

close derivative of the Dome of the Rock stands on its virtual Sacred Esplanade. Sentinels look down at us from the balconies of complex watch-towers among the palms, and through triumphal gateways we glimpse spacious boulevards. A long line of turrets guards a city wall, there are eques-trian champions on high plinths or pillars, what looks like a pyramidical tomb, a profusion of domes and wind towers. An inn-sign hangs out-side a monumental city portal, a public fountain has a stately pavilion of its own, a castellated bridge gives access to a majestically towered palace. And if you tire of the great city, you can always follow the odd horsemen or pedestrians up their winding path to a lesser town cloistered on the hill above, or leave little Jesus playing with the Baptist among the relatives to visit the delightful pleasure-town in that green valley beyond.

Mind how you go, though. Wherever you wander in this virtual city, knights are liable to be

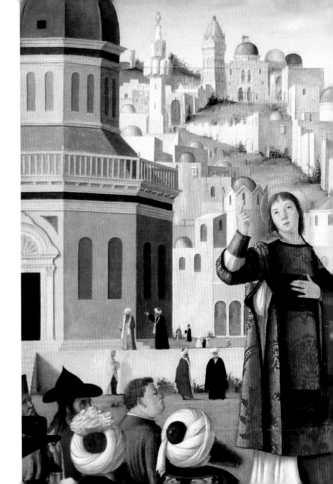

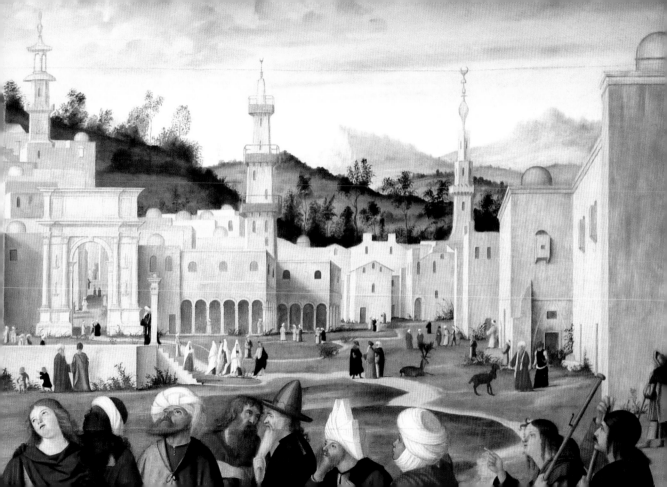

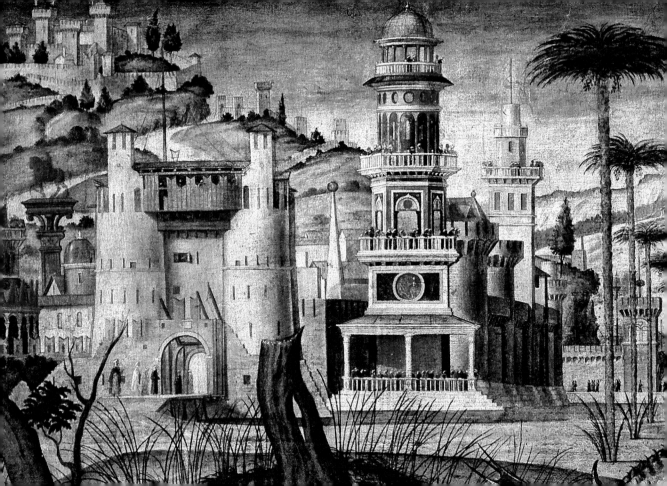

slaying dragons, demons are being exorcised, pagans are being publicly converted, saints are preaching or having debates with rabbis, diplomats are reporting to kings, monks are running away from tame lions and horrid basilisks are on display. Often you may be caught up in crowds attending one civic event or another, massed on terraces and staircases, or you may be deafened once again by crimson trumpeters in astrakhan hats.

And curiously enough, you may well find yourself drawn back to the very building that so inspired my Begw. It is pure Carpaccio Style. You can view it best from the battleground of St George and the dragon, if you are careful not to stumble upon any eviscerated corpses. It stands near one of the horse-back heroes, at the foot of the path to one of those ancillary towns, and it defies conventional analysis. It is a kind of gateway with a drawbridge, with two heftily connected towers flanking a horse-shoe arched entrance. Three protruding beams carry chains to work the drawbridge, and there are external steps for its operators. Each tower is surmounted by a smaller turret with a pyramidical roof, and these are linked by a large wooden bridge with a flagstaff on top, and with five windows in which you may observe the turbanned heads of men on sentry-go. There are arrow-slits all over the structure, too, and a small central window with another watchful head in it, and altogether it is a stalwart, carefully conceived work of fancy.

Not altogether fancy, though, because European travellers of the day were greatly impressed by the city gates lately erected in Cairo by the Fatimid rulers of Egypt, and one of them, the Bab al Futuh which still stands, might easily be a hearsay model for Carpaccio's gate. Vittore was clearly pleased with his version, anyway - he built it in three different locations, confirming Begw's instincts about its properties.

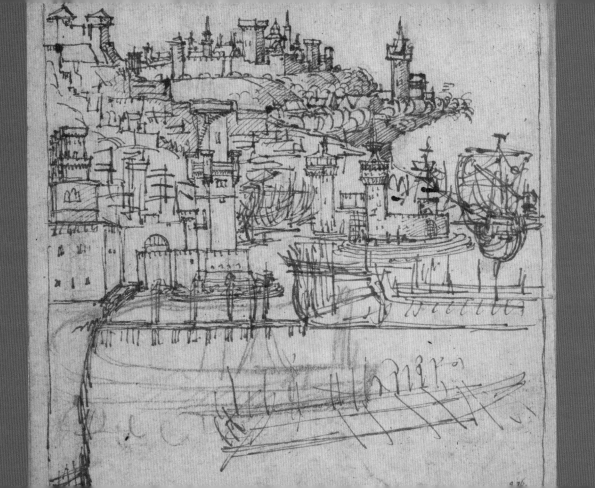

8. To shape, fashion or mould

Scholars have observed that Carpaccio, in signing his pictures, habitually used the Latin verb *fingere*, meaning, my dictionary tells me, to shape, fashion or mould, rather than the more usual *facere*, to make. Only gradually did I come to accept that Carpaccio's easy allure is only the icing on the cake. I used to agree rather with Rebecca West, who once defined his art as being simply 'at once pious and playful, luxurious and simple-minded', and Ruskin's responses were more or less my own. He began by disregarding Carpaccio altogether, during his impassioned Venetian researches. Then he evolved the magic mirror theory, claiming that Vittore should never be taken really seriously. And finally he recognized that here was a creative artist of subtlety and suggestive power, by no means just a charmer.

So did I, when I realized the complexity of his purposes.

The pro

For one thing, Carpaccio was the complete professional. As I see it, his inspirations were not of

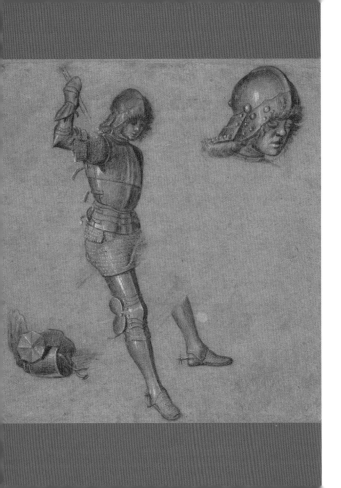

the blazing, instant kind, but were very carefully nurtured. Like almost every other artist, he was not above borrowing other people's techniques, or assimilating their ideas. The landscapes in the backgrounds to his pictures could sometimes be interchangeable with those of his Venetian contemporaries — only the intricate details are uniquely his — and over the years he built up a sort of memory-bank of images, as we can see from his notebooks. There he assembled a gallery or stockpile of drawings — of faces, of figures, of designs, of constructions — from which he could pluck examples as required. Some critics have suggested that this contributes to the sense of reassuring familiarity that infuses Carpaccio's work, and I think they may be right.

Certainly for addicts like me old friends crop up all over the place in his pictures, characters we half-recognize, buildings we have surely already explored, faces we think we know. There are standard pagans in standard turbans. Boatmen

and old women recur. Is that the King of the Bretons, or just one of the Rialto crowd? The scribe who is keeping a record in the royal palace of Brittany is still at it in the next picture of the cycle, taking notes on a balcony above the harbour. The person I took to be a midwife in one picture appears as the Madonna herself in another. Precisely the same jawbone lies beneath the belly of St George's dragon and on the field of Golgotha. The same stag grazes in the Bethlehem monastery on the day Jerome arrived with his lion, and on the day he died. The building that entranced Begw out of a Carpaccian Libya can entrance us still, if we look hard enough, from more than one Palestinian hill-top.

He was, after all, working always to a commission, and to an object. The throw-away style of the *Miracle of the True Cross at Rialto* is not really throw-away at all. The miracle had only just been performed, and Carpaccio's remit from the Scuola di San Giovanni, as I take it, was to

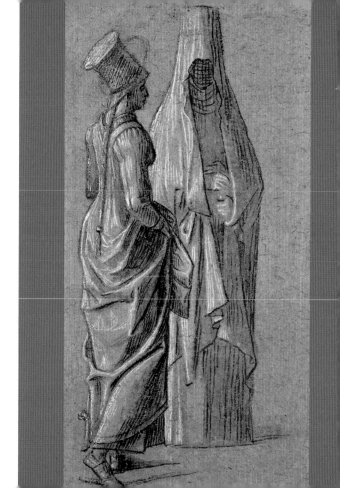

emphasize how absolutely part of everyday life, how wordly in fact, was the divine purpose — and indeed the sacred reliquary of the miracle is still around today, in the very same School of St John the Evangelist that commissioned the picture. Carpaccio's great *Lion of St Mark*, however I have chosen to interpret it, was really a terrific work of publicity for the State, and all the operatic dazzle of his style contributed to the Serenissima's gorgeous reputation — as it still does, five hundred years on.

Symbolical?

Then again, purposeful symbolism figures constantly in Carpaccio's work. I always used to be tempted to ignore it, sometimes because I didn't believe in it, partly because I preferred to do without it, and partly because I often found scholarly interpretations of its signs unconvincing.

I had a point there, too, as is demonstrated by the history of one of the most famous of all Vittore's paintings, the one with the Carpaccio Dog in it, for several centuries known as a portrait of St Jerome at work in his study. The picture offers an exact evocation, we must suppose, of his work-place. The papers on his desk, with a pair of scissors, are there to be intimately examined, as are the knick-knacks on his shelf, the line of 94 books in bindings of various colours, a cupboard door-lock, an astrolabe, candlesticks, a bishop's mitre, an hour-glass and the perky little white dog in the middle of the room. Two music scores are lying around, open to performance - one is a solemn song for male voices, the other something lighter, a drawing-room ballad for soprano, contralto, tenor and bass. People can still perform them today. Everything in that room is rational, clear-cut, precisely illustrative, and I take endless pleasure in exploring the details of the scene.

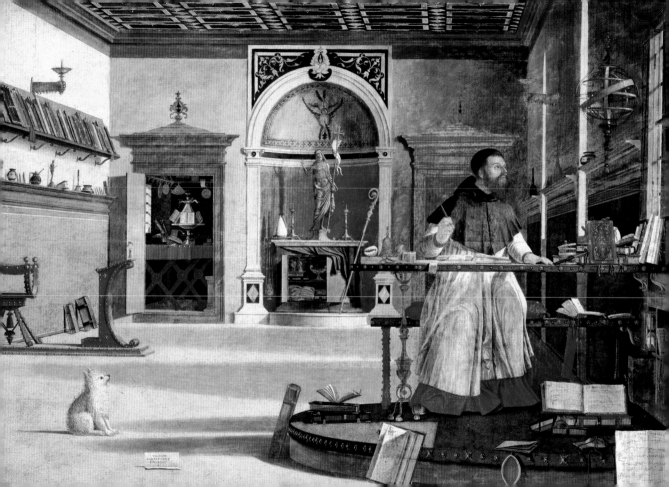

Years ago a magazine invited me to name my favourite painting, and I chose this one. I interpreted for my readers the scholar-saint sitting in his sun-lit study chair meditatively looking out of the window, pen in hand, trying to think of a word perhaps, while the dog sits there on the floor wagging its tail and dying to go out for a walk. I imagined the scene to represent the cassocked divine lost in thought, the dog affectionately willing its master to take a break, and all around, in the Carpaccian way, the room littered with the bric-a-brac of a civilized household — the whole thing pictured, I liked to think, on a spring mid-morning, when the sun shone gently through the window.

Ruskin was persuaded otherwise. He thought it showed St Jerome in Heaven, fulfilling all the noblest desires of the human spirit, surrounded by emblems of music, painting, sculpture and literature, attended by the happy fidelity of his dog as he prepares to enter the

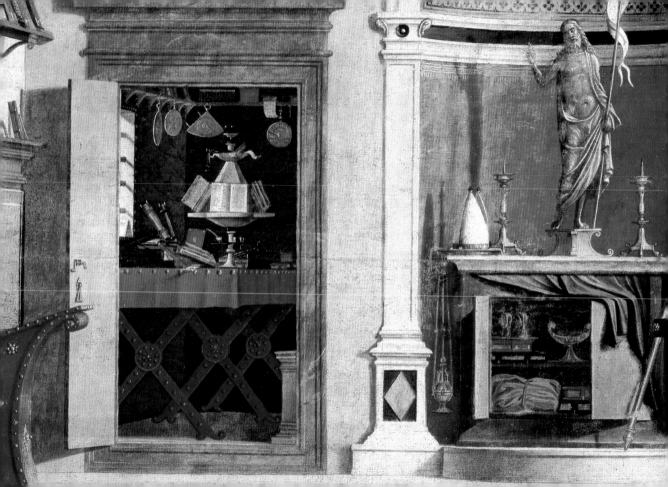

mansions of immortality. The sunlight in his study is the light of Heaven itself. He is not trying to think of an adjective, but listening to the Word of God. And every object in the room, every statuette and document and book and candlestick has its own symbolic significance.

We were both misled, and there were clues to our errors. For one thing, where is Jerome's lion? In almost every representation of St Jerome, he is accompanied by his iconic lion. All we get here is that little dog. For another thing, the picture hangs as one of three that Carpaccio painted in a cycle about the life of St Jerome, but in neither of the others does the saint look remotely like the man pictured here: in this one he is a worldly intellectual, in the others a rustically simple monk.

Quite so, learned people have lately told us, because it is not really St Jerome at all in the picture, and he is not just trying to think of *le mot juste*. He is St Augustine (died 430 AD), and he is

seeing through his window an apparition of St Jerome, announcing his own death at that very moment in Bethlehem. The window-light is not my fresh morning sunshine, calling Jerome to exercise, or Ruskin's benign light of heaven, but the miraculous radiance of the vision outside, and the dog is not looking impatiently at his master, but is taken aback by the sacred effulgence. Jerome was never a bishop, those sages say, so there wouldn't be a mitre lying around the house, and why do you suppose there are 94 books on that shelf? Because Augustine wrote 94 books, that's why, and Jerome didn't.

Elsewhere in Carpaccio's symbolisms, too, interpretations can be misleading. For years we were told that the presence of a scorpion in one of the Ursula cycle pictures was simply a medieval symbol of doom and malignity, until it dawned upon some astrologer that on the Feast of St Ursula (October 21) the sun entered the sign of Scorpio. Or take that famously ambiguous painting called *The Two Courtesans*. To me it is a study of disillusionment, an illustration of wasted life, in which two elderly whores wait for the clients who never come, and are left only with the company of dogs, pigeons, a peahen and a parakeet, stared at through the balustrade by an idle urchin. For others, since there appears in the picture the crest of a noble household, it is a dig at social pretension, two old aristocrats contemplating the emptiness of grandeur, their only lackeys two dull dogs and an impertinent yokel. One scholar thought the woman holding the stick might represent Circe, the dog at the other end of it being one of her ex-humans. Ruskin, who once wildly pronounced it in certain respects The Best Picture in the World, declared himself quite sure that it was 'a simple study of animal life in all its phases', perhaps with a tinge of satire concerning the vices of Venetian society – for there is a pair of expensive-looking pattens in the corner of the picture, and everybody

knew that in Carpaccio's day shoes were 'the grossest and absurdist means of expressing female pride'. In the 19th century the picture was catalogued as *Two Young Witches*; nowadays it is more often called simply *Two Women*, enabling other theorists again to emphasize the picture's varied traditional emblems of faithful chastity – lily for virtue, myrtle for constancy, doves for love, dogs for affection and so on.

Alas for dogmatics, altogether new theories have lately arisen. Remember that slap-stick picture of the so-called duck-hunt on the lagoon, with comical hunters and unconvincing bird-life? It has now been established that it was not an independent painting but part of a larger one and that *The Two Courtesans* was another section of the same picture. A plant in a vase in the room of the courtesans actually overlaps the hunt, implying that we are looking at the lagoon from the ladies' balcony. This unexpected extension – men having fun in the lagoon, women

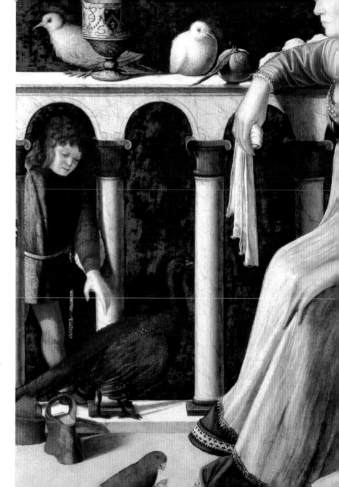

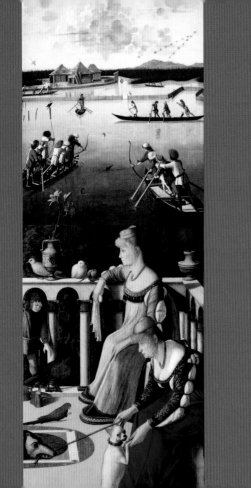

bored stiff indoors – encourages one commentator to describe the complete ensemble as 'almost didactically proto-feminist'.

Symbolical

All the same, the prevalence of symbols in Carpaccio's work is undeniable. They proliferated in everybody's art in those days, and I can only suppose that the general educated public knew what they all meant. For myself, I rely in the first instance upon Brewer's *Dictionary of Phrase and Fable* (1894 edition), and this is how it has interpreted for me the symbolisms of the menagerie in the picture of the *Young Knight* with which I opened this book. The hares, Brewer tells me, symbolize Timidity. The frogs stand for Inspiration. The rabbits, of course, mean Fecundity, when they don't mean Timidity too. The dogs imply either Fidelity or Dirty Habits.

The stag is a Cuckold, the peacock is Pride, the vulture is Horribleness, the horse Speed and Grace, the Guinea-fowl is Foolishness, the stork took its name from flying around Christ's Cross, crying in Swedish *Styrka! Styrka! Strengthen! Strengthen!* Mr Brewer does not offer a symbolism for the ermine, but I happen to know that in Carpaccio's day its name was synonymous with everything pure, innocent, royal and conducive to human childbirth – the very opposite of the weasel or stoat, which is what it really is.

Where does that get me? No closer, alas, to a meaning of the picture itself, and often enough Carpaccio's inner meanings are certainly cryptic. It has been suggested, for example, that the whole of the Ursula cycle really illustrates the story of Caterina Cornaro, the Venetian-born Queen of Cyprus, whose family had close connections with the School of St Ursula. The critic Jan Lauts, in 1960, carefully analysed the mystical and symbolical significances of Carpaccio's

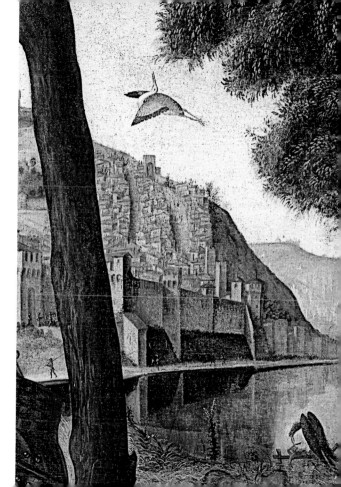

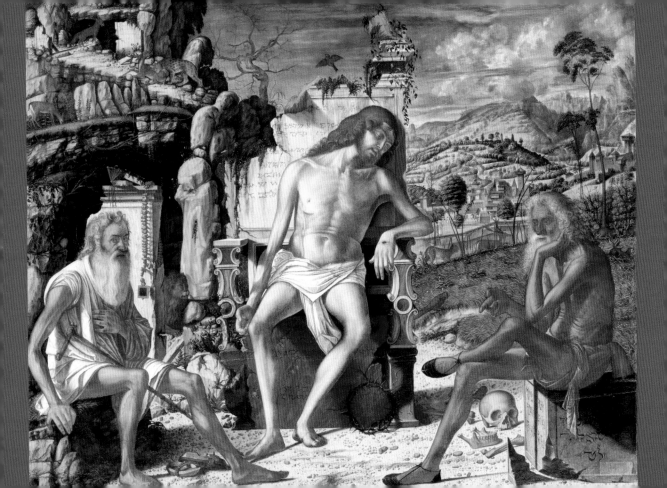

Meditation on the Dead Christ, in the Metropolitan Museum in New York. This devotional picture shows Job and St Jerome seated beside the dead Christ in a desolate place, pondering the meanings of the Passion. Almost everything in the picture, Lauts demonstrates, is symbolic. Christ is pictured as the universal Man of Sorrows, and the two mourners are great men of the Faith, one from the Old Testament, one from the new. A bird flying from the scene foretells the Resurrection, sprouting plants symbolize new life. While one stag is savaged by a leopard in the wilderness, like mankind lost without the knowledge of Christ, another escapes into a flowery place, saved by conviction. The mystic number 19 on a broken stone is the number of a chapter in the Book of Job which contains the ultimate words of belief: 'My Redeemer Liveth'.

Then again, the strangely miscellaneous creatures in the courtyard of Jerome's monastery have all been identified as metaphysical. Some

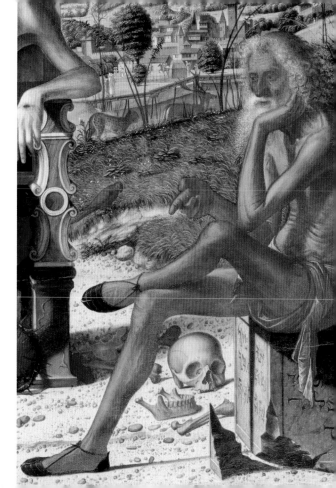

stand for foolishness (like the panicky monks perhaps), some for useful dedication and solitude (the monastic ideals) and the parrot represents eloquence, one of Jerome's own gifts. As for the two grazing donkeys, each of them remembers a separate fabled episode in the saint's hagiography. (Whether there is a hidden meaning to the washing that hangs from the monastery windows we are not told, but I wouldn't be surprised, and I can easily invent one anyway...)

There are a myriad such allusions, distributed throughout Carpaccio's work. One needs a guide to grasp some of their obscurities – for example the odd prevalence in his pictures of a pointed index finger – but many of them are simple enough, and often touching. The two halves of *St George's Triumph* are clearly divided into emblems of death and life. On the left are bones and corpses, withering leaves, a pagan city, alien trees, a ship skulking in the lee of the land and a doomed monster with a spear through its snout: on the right green leaves are flourishing, familiar trees provide shade, beautiful ships are gliding by, the handsome saint-knight gallops into action, and standing in gracious wonder at the edge of the action is the beautiful princess herself.

In the *Holy Family* picture the two deer under the bridge, in the happy presence of the infant Jesus, are tenderly licking each other – in direct opposition to the leopard which, in the *Meditation*, is savaging another deer, in the tragic presence of the dead Christ.

So *what*?

Symbolisms apart, anyway, much of the delight of the paintings is their subtle confusion of truth and imagination, the dismissal of logic applied with such infinite accuracy. It is another world that Carpaccio is creating, reality of another kind.

In its arcane mixture of fact, illusion, allegory and entertainment it reminds me of the *Mabinogion*, the great corpus of medieval Welsh legend – or, from our own times, the literary movement called Magic Realism.

For generations the Jerome picture was known and beloved as *St Jerome in his Study,* now it is known as *The Vision of St. Augustine.* But so what? The most civilized of all Venetian commentators, J. G. Links, wrote that he would 'pass over with the contempt it deserves this attempt by art historians to deprive us of our most cherished traditions'. Everybody knows, said that champion of everything delightful, that the picture is *St Jerome in his Study*, and I agree with him.

(Well, up to a point…)

9. Legacies

They are oddly muddled legacies, anyway, that my friend Vittore has left behind him. Not only dullards, but many highly cultured people think instantly of cooking when I mention his name. (Have you tried Octopus Carpaccio with wild aragula and a spunky anchovy sauce at Bestia Restaurant, Los Angeles? Or Carpaccio of Beetroot, blood orange, feta and baby herbs at the Port Philip Estate Winery, Red Hill, Victoria? Or for that matter the original Beef Carpaccio at Harry's Bar in Venice, where the dish is garnished with a secret dressing drizzled over the beef in, I am told, a 'cross-hatch, Kandinsky-style pattern'? Sensational!)

You require a monument?

By and large it seems to me that in Britain and America, at least, only those who have been to Venice know just who I am talking about, when I mention Carpaccio, and their faces light up when they remember him. Even in Venice itself, though, even in his own lifetime, he died in eclipse. It is an irony of art history that in 1508 he

was commissioned by the Signory to judge the work of two young artists who had been employed to paint frescoes on the walls of the Fondego dei Tedeschi, the German trade head-quarters at the Rialto. Fifty years old himself, he was chosen for the task as one of the supreme Venetian masters of his day, but as it turned out the artists whose work he was to judge were principal agents of his nemesis – Giorgione and Titian. Their revolutionary images were to propel Venetian art into the sensual splendours and spir-itualities of the High Renaissance, and make the Carpaccian Style almost instantly obsolete. (Carpaccio's judgement of the frescoes is not recorded, but their only surviving examples, the ectoplasmic remnants of Giorgione's contribu-tions, are reverently preserved at the Franchetti Gallery in Venice to this day.)

Vittore's last years seem to have been a long decline. He was out-of-date, and perhaps lost heart. All the critics seem to agree that his gifts faded, and even I find many of his later pictures short of inspiration, spontaneity or even fun. After the splendid metropolitan commissions of his prime he was gradually reduced to painting altar-fronts or organ-cases in country churches. Titian, after his death, was honoured with a stu-pendous monument in the great church of the Frari. Carpaccio has no monument at all, except in his works and in the minds of his admirers.

The improbable champion

But although his reputation among the cognoscenti languished for centuries after his death, it was to be revived largely by the para-doxical influence of John Ruskin. As we know, at first Ruskin considered him a lightweight – just a charming mirror-image man – and he took no notice at all of Carpaccio's pictures when he himself first came to Venice in 1835. In 1869,

however, for the first time he visited the Schiavoni building (remember the way? Right at the T-junction?) and entered an infatuation far more fateful than mine.

First he became obsessed with the notion of St George as embodied there by Carpaccio – the perfect knight, as Ruskin wrote, pictured in immortal chivalry. Just such a knight, he thought, was needed to rescue England too from the various evils that beset it, and so in 1878 he founded the Guild of St George, a quixotic social movement whose purposes were to confront England's dragons with the same fearless chivalry with which Carpaccio's St George confronted Silene's.

The Guild survives in England, and still bravely labours in its various causes, but Ruskin's personal Carpaccio involvement went much further. He moved on from dragons and chivalry in the St George cycle to love and passion in the cycle of St Ursula – from the killing-ground in Libya to that comfortable bedroom where Ursula had her fateful dream. In his early middle age he had fallen desperately in love with a young woman, Rose la Touche, who remained an ideal for him until her death at the age of only 27. By then he was beginning to lose his mind, and to succumb to his Carpaccian obsession, and in a crazed and sexual way he came to identify his virgin paramour Rose with the virgin saint Ursula, as represented in particular in Carpaccio's *The Dream of St Ursula*. He painted a meticulous water-colour copy of the picture, now in the Ashmolean Museum at Oxford, and wrote that sometimes being alone with the sleeping girl, while he painted her, felt 'quite improper'…

Later still, when he came to dabble in spiritualism, Ruskin fancied that Ursula was a medium keeping him in touch with the departed Rose; and so the dead woman, the mythical martyr, the city of Venice and our friend in

common, Vittore Carpaccio, all seemed to have been confused in his decaying mind, and remained with him, spiritually, artistically and erotically, until his enthusiasms were subsumed at last into madness and death.

Before then, though, he had done much to rescue Carpaccio from his centuries of oblivion, and at home in England Ruskin was to boast that he alone had introduced Vittore to the art-loving public of the 19th century. Not just the art, he claimed, but even the name of Carpaccio was unknown to the wider world until then: and it is certainly true that when his great admirer Proust dreamed a dream of Venice, in *Remembrance of Things Past,* it was an undeniably Carpaccian Venice that provided its images – 'thanks to the echo', wrote Marcel, 'itself imperceptible, of a last note of light…'

In the pantheon?

Yet Carpaccio has never been generally accepted into the supreme pantheon of art. Devoted (if ignorant) advocate though I am, I would not promote him there myself. He was certainly a true original – not only has he been called, at one time or another, the first great maritime painter and the first Orientalist painter, but his picture of Ursula's bedroom has been judged the first true interior, and the *Young Man at Madrid* is said to be the first full-length portrait in Italian art. In 1911, however, the *Encyclopedia Britannnica* could only describe Carpaccio as a 'precursor' of the Venetian masters, and in E. H. Gombrich's influential *Story of Art* (1950) he is not mentioned at all.

For me too he lacks the aura of tremendous sublimity that the very greatest practitioners have projected down the ages, but instead I think he may possess some separate, simpler genius.

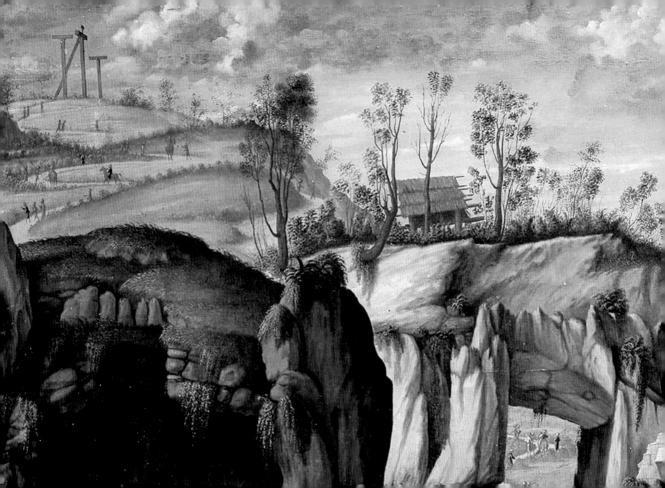

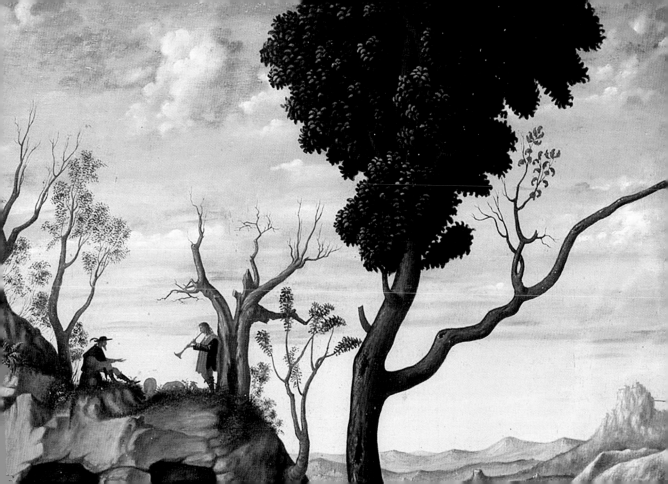

10. A simpler kind of genius?

High on the left side of Carpaccio's picture of the slaughter at Mount Ararat, amidst the writhing twisted horror of the martyrdom, the naked corpses everywhere, the random crucifixions, the ghastly confusion of it all – high on the left side, unassertively in the middle distance, there is one familiar figure to redeem the message of the scene. It is Christ himself, in searing anachronism upon his own cruel cross, and his expression of agonized compassion elevates the work to another dimension altogether.

For years I did not notice it there, but I was glad to find it in the end, because scenes of unrelieved misery and torture never seem Carpaccio's natural style. I have shied away, too, from his picture *The Blood of the Redeemer*, because I find his fastidious manner ill at ease with the medieval convention that imagined the blood of Christ squirting accurately into a chalice out of his own wounds – a repellent metaphor for my own tastes, and I would think for Vittore's too.

I may be wrong there. The cult of the Holy Blood was rampant in Italy in those days, and for all I know Carpaccio may have been a devotee. My feeling is, though, that he was a man of reli-

gion, but not of religiosity. He was a Christian by birth and by profession, in the sense that during his entire working life he depended upon the patronage of the Church and its dependencies: but his Catholic Christian faith, it seems to me, was essentially untrammeled and down to earth – in another incarnation he might have been a merrier kind of Quaker. Carpaccian miracles are performed with a minimum of fuss, stripped of showy mysticism, and on the Carpaccian stage the players of the great Christian pageant generally seem to be straightforward folk, summoned almost without their knowing it into the most tremendous of roles.

The spiritual side of his art does not show itself most powerfully, I think, in the narrative canvases, painted for the pious and powerful scuole and now the most famous of his works. Their stories are holy stories indeed, concerned with Christian saints and divines, Godly feats and martyrdom. But in those paintings the ambience of Magic Realism or *Mabinogion* is so powerful, the colours and activities are so vivacious, there is so much fun and fascination to it all, that devotional aspects tend to be out-dazzled. In the great body of Vittore's other work, however, painted for individual patrons and less indebted to the seductions of the Golden Legend or the popularist demands of the scuole, I feel I can better gauge his true moral calibre. Two paintings in particular seem to me divinely inspired, and they both concern death and suffering.

The first expresses absolute sadness. *The Entombment of Christ* at Berlin is the one in which we see the elderly Virgin Mary close to collapse, in a landscape littered with bones and skulls representing, as we know from another context, the Field of Golgotha. The misery of the scene is absolute. On a ridge above we see the shepherd piper whose melancholy lament we have already heard, and at the very top of the picture are the three crosses of Calvary, alone in

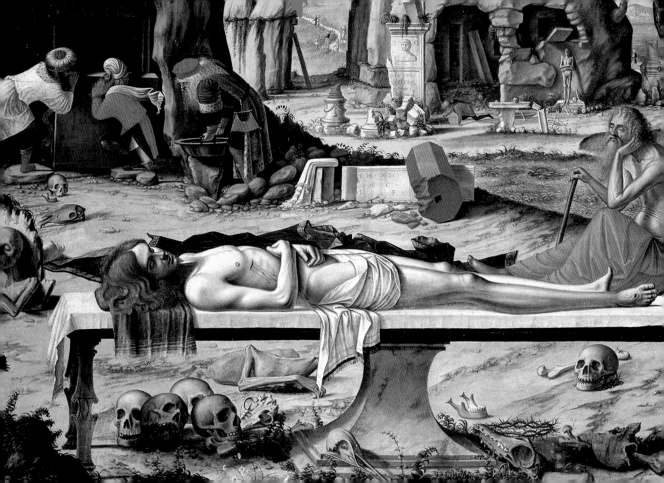

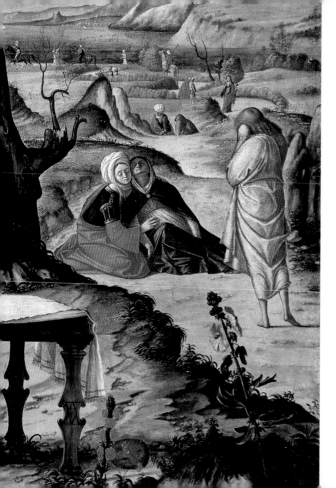

an empty desolation. In the foreground the dead Christ lies stone-cold on his bier, surrounded by symbols of despair – dark twisted trees, broken memorials of lost grandeur, an apparently abandoned homestead, the rock-tomb being prepared for the burial. Thunder-clouds are gathering, and in the middle of this dreadful prospect is a lone bearded mourner, propped uncomfortably against a tree-trunk.

The mourner appears again, in identical pose, in Carpaccio's other great picture of passion, his *Meditation on the Dead Christ* at New York. This time, however, I interpret the picture's inner message as one of hope. It is true that the mourner turns out to be Job, the quintessential man of suffering, and his index finger is pointing meaningfully at the ground itself. He and our old acquaintance Jerome are sitting one on each side of a Christ who has been brought down from the cross, and the immediate setting is dismal still, with a skull and a jawbone promi-

nent, and Jesus sitting on a grandiose broken throne with his crown of thorns discarded at his feet. But the wider prospect is of green lush fields and pleasant towns (a suggestion of Begw's building in the distance), and when we look harder we realize that the scene really bursts with life in all its richness. Five of Jerome's inspirational books are waiting in a pile to be read, a parrot is hopping about, two leopards chase two stags, some kind of little lion is cheerfully peering around a pillar, and I think I can see a fox lurking among the rocks. A gentle Jesus, though clearly exhausted, does not look unhappy, but more relieved that the worst is over, the best yet to come, and in the sky above a bird, flying joyously into the firmament, expresses the promise of resurrection.

Could it be the very same bird that so excited me, when I found it in my computer at the start of this escapade? Perhaps, because now I feel I am reaching some kind of conclusion, and that

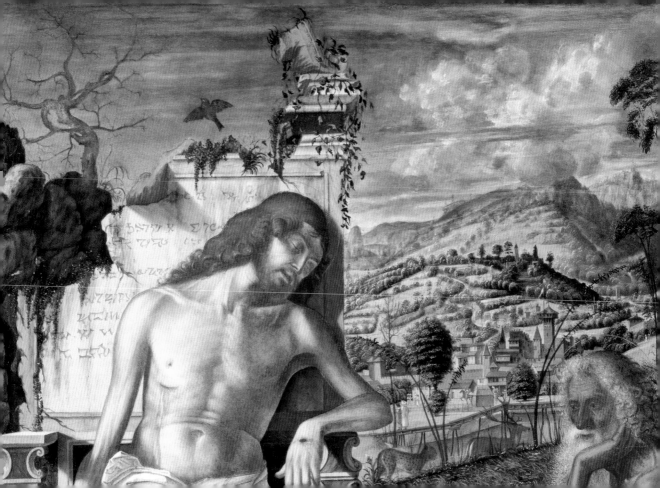

Vittore has told me all that he will reveal about himself. What sort of person have I discovered, behind that inquisitive face, under the black hat of Venetian fashion?

The Carpaccio Man

'*Le style est l'homme même*', de Buffon told us long ago, and I think it is true – I hope it is true! – that in Vittore's art I can properly discern the character of the man himself. I do not know what he looked like, but I know what he feels like to me - not just as a stylist, but as a friend.

His tastes are obvious – for colour, for splendour, for swank. His intellect was, I would guess, scintillating rather than deep. His humour could be puckish but could be broad. His extra-professional interests were wide – ships, architecture, botany and zoology. If he had hobbies, they might have been of a practical kind like wood-working, but he was keen on sketching and doodling for pleasure, too. He was a Venetian patriot but not, I prefer to think, of the conformist kind, and I feel sure he was a conscientious family man. I don't doubt that he was very aware of his own abilities, and rather too reluctant to recognize the fading of his powers in the face of old age and changing fashion. We have seen that his religion, though generally moderate, could flame into passion when pathos or suffering fired it.

And for me his true genius showed itself most clearly of all not in the enchanting fantasies of the legendary cycles, nor even in the great devotional studies, but in a generally less-regarded work: that same *Presentation of the Virgin* which hangs in the Brera Gallery in Milan, and which we visited a few pages back. It is not one of his virtuoso pictures, although in its background stands a wonderfully flamboyant version of Jerusalem, with a five-storied tower of some sort, an elaborately embellished dome, one of

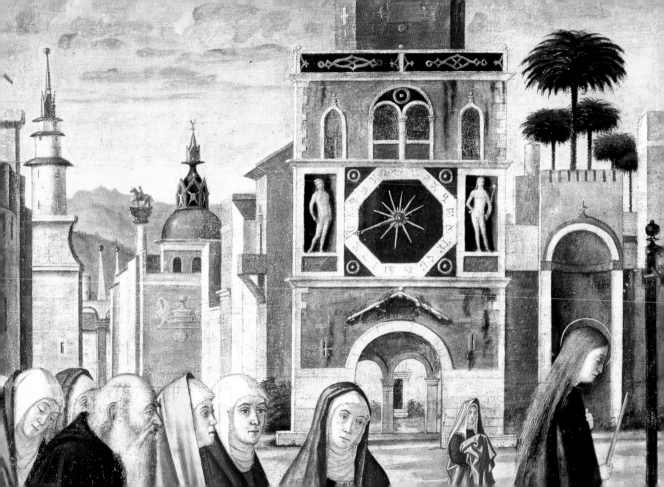

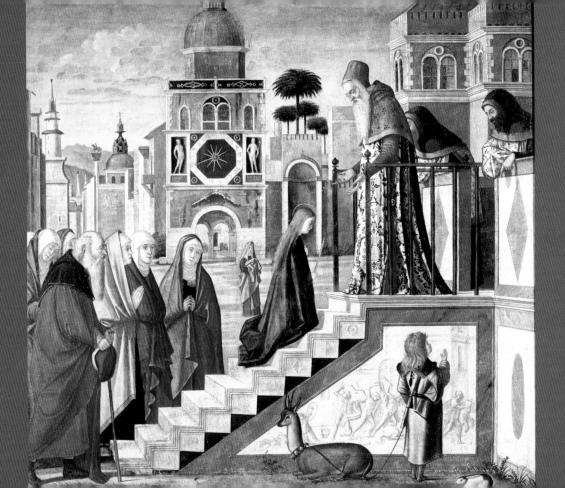

those equestrian champions on a tall pillar and an amiable Codussian-style constuction which seems to be partly the Dome of the Rock in Jerusalem and partly the clock tower in the Piazza at Venice. For the rest, though, the tone of the scene is altogether gentle.

Little Mary kneels thoughtfully, holding a silver wand, on the steps of the Temple, while the old High Priest waits to receive her on the platform above. A solitary woman bystander stands at a reverent distance in the square behind. Mary's mother and father, like parents seeing off their child to summer camp or boarding school, stand anxiously but proudly at the foot of the steps, with a few friends, and in the foreground there is a little tableau which establishes for me the whole meaning of the picture.

Down there a small boy in a long coat holds on a lead a lovely Carpaccian animal – deer-like, long-eared, twin-horned, graceful, benign and perhaps chimerical. The child is chatting to one of the temple priests, who is leaning fondly from a balcony above with his forefinger pointing at the child, and the whole scene is completed by the presence of a small black and white rabbit, at the very bottom right of the composition.

I love this calm and touching picture, and I think it seals my Carpaccio infatuation, encapsulating my view of Vittore the man, and the true nature of his genius. I believe he is above all a supreme artist of that simple, universal and omnipotent virtue, the quality of Kindness.

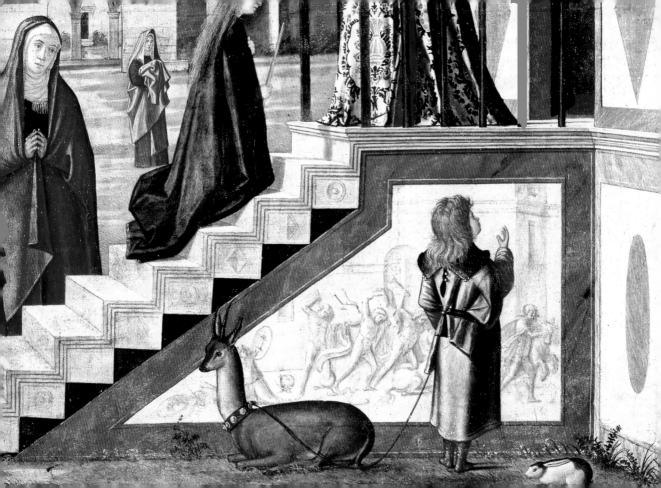

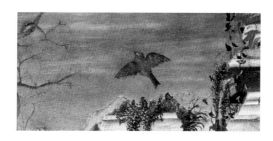

Arrivederci!

So the small bright bird and I have returned to
our own worlds – it to the high empyrean,
me to my books by the fire.
Arrivederci, Vittore!
I called as we parted.
Diolch o'r galon, cariad!

Trefan Marys, 2014

Checklist of works by Carpaccio

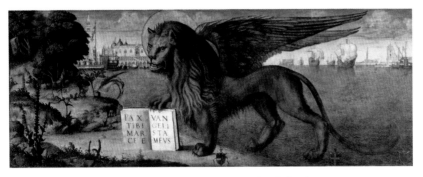

Lion of St Mark, oil on canvas, 130 x 368 cm, signed and dated 1516
Venice, Doge's Palace
Reproduced pp. 30-31, detail pp. 32-33

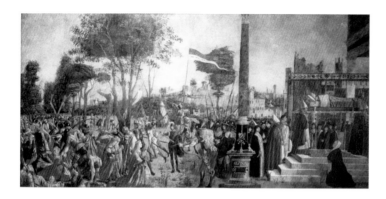

Martyrdom of the Pilgrims and the Funeral of St Ursula
Oil on canvas, 271 x 561 cm, signed and dated 1493
Detail reproduced p. 25

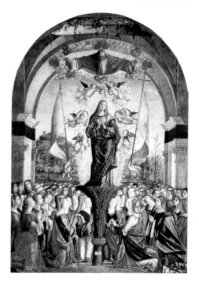

Apotheosis of St Ursula
Oil on canvas, 481 x 336 cm,
signed and dated 1491

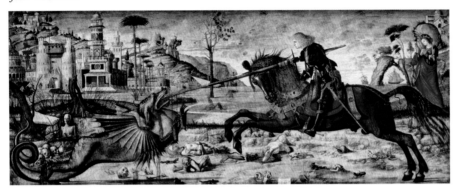

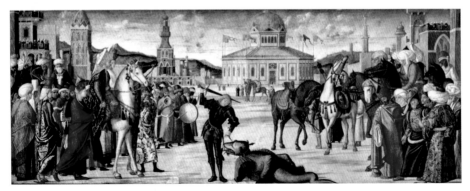

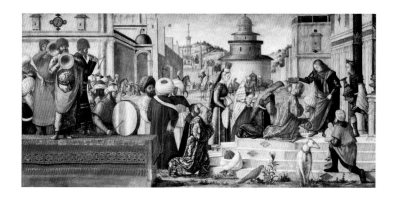

EPISODES FROM THE LIVES OF STS JEROME, GEORGE AND TRYPHONIUS, C. 1500–1507

SCUOLA DALMATA (OR DI SAN GIORGIO DEGLI SCHIAVONI), VENICE

Opposite, top:
St George and the Dragon, oil on canvas, 141 x 360 cm. Details reproduced on pp. 48-49, 52-53, 116 and 134

Opposite, bottom:
Triumph of St George, oil on canvas, 141 x 360 cm. Reproduced pp. 68-69, details on pp. 26 and 80

Above
St George baptises the Selenites, oil on canvas, 141 x 285 cm, signed and originally dated 1507
Reproduced pp. 76-77, details on pp. 57, 70 and 75

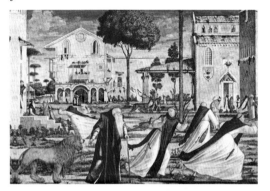

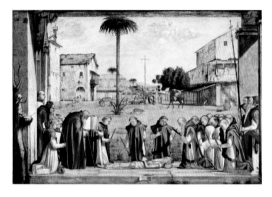

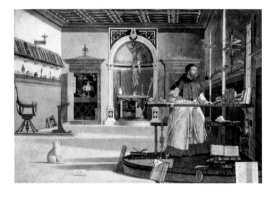

Above, left:
St Jerome and the Lion, oil on canvas, 141 x 211 cm
Reproduced p. 64, details pp. 100, 101 and 102

Above, right:
Funeral of St Jerome, oil on canvas, 141 x 211 cm, signed
and dated 1502
Detail reproduced pp. 54-55

Left:
Vision of St Augustine, oil on canvas, 141 x 210 cm, signed
Reproduced p. 141, details pp. 1, 58-59, 142-145 and 153

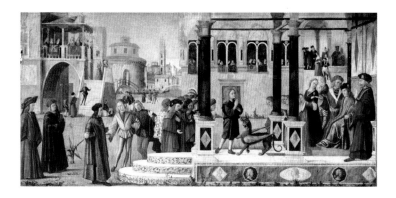

*The Daughter of the Emperor Gordian
Exorcised by St Tryphonius*
Oil on canvas, 141 x 300 cm
Reproduced pp. 36–37, details on
pp. 34, 38 and 56

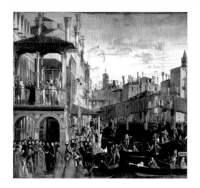

MIRACLE OF THE RELIC OF THE TRUE CROSS
ORIGINALLY SCUOLA DI SAN GIOVANNI EVANGELISTA,
NOW GALLERIA DELL' ACCADEMIA, VENICE

Healing of the Possessed Man at the Rialto Bridge
Oil on canvas, 363 x 406 cm, probably 1495
Reproduced p. 43, details pp. 42, 43, 44–45, 118–119, 120 and 130

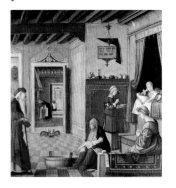
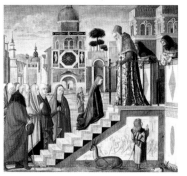
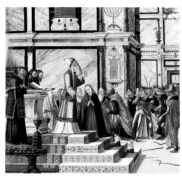

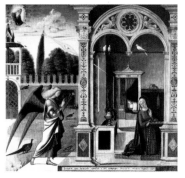
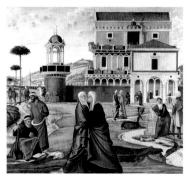
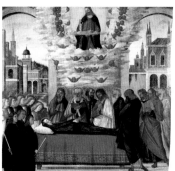

EPISODES FROM THE LIFE OF THE VIRGIN, C. 1502–7,
ORIGINALLY SCUOLA DEGLI ALBANESI

Top row, left to right:

Birth of the Virgin, oil on canvas, 126 x 129 cm, signed
Bergamo, Accademia Carrara
Reproduced p. 91

Presentation of the Virgin, oil on canvas, 130 x 137 cm
Milan, Pinacoteca di Brera
Reproduced p. 92 and p. 170, details p. 169 and 172

Miraculous Flowering of the Rod (Marriage), oil on
canvas, 130 x 140 cm. Milan, Pinacoteca di Brera
Reproduced p. 93

Bottom row, left to right

Annunciation
Oil on canvas, 127 x 139 cm, inscribed 1504
Venice, Galleria Franchetti all' Ca' d'Oro
Reproduced p. 93, details pp. 83-84

Visitation, oil on canvas, 128 x 137 cm
Venice, Museo Correr

Death of the Virgin, oil on canvas, 128 x 133 cm,
inscribed 1504
Venice, Galleria Franchetti all' Ca' d'Oro

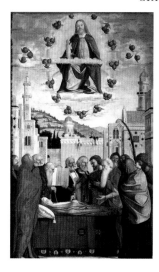

Death of the Virgin
Oil on canvas, 242 x 147 cm,
signed and dated 1508
Ferrara, Pinacoteca Nazionale

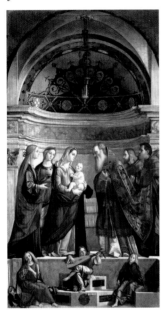

Presentation of Jesus in the Temple
Oil on panel, 421 x 236 cm, signed and dated 1510
Venice, Galleria dell' Accademia
Details reproduced pp. 86-87

EPISODES FROM THE LIFE OF ST STEPHEN 1511–1520

ORIGINALLY SCUOLA DI SANTO STEFANO

Opposite, top left:
St Stephen is consecrated deacon
Oil on canvas, 148 x 231 cm, signed and dated 1511
Berlin, Staatliche Museen, Gemäldegalerie

Opposite, top right:
Preaching of St Stephen
Oil on canvas, 148 x 194 cm
Paris, Louvre
Details reproduced pp. 78, 79 and 132-133

Opposite, bottom left:
Disputation of St Stephen
Oil on canvas, 147 x 172 cm, signed and dated 1514
Milan, Pinacoteca di Brera
Reproduced p. 21, details on pp. 14, 22 and 23

Opposite, bottom right:
Stoning of St Stephen
Oil on canvas, 149 x 170 cm, signed and dated 1520
Stuttgart, Staatsgalerie

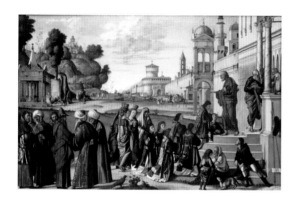
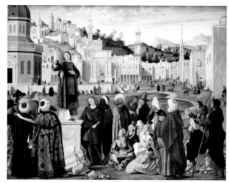
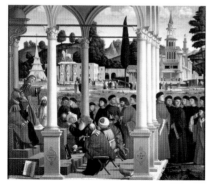
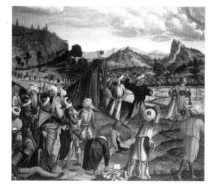

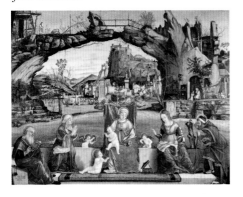

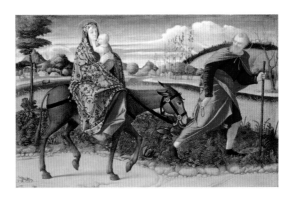

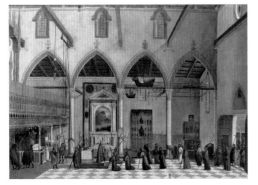

Above, left:
Holy Family with Saints, oil on canvas, 98 x 127 cm, signed, *c.* 1505-1512. Avignon, Musée du Petit Palais
Reproduced p. 89, details pp. 88, 122-123 and 124

Above, right:
Flight into Egypt, oil on panel, 75 x 112 cm, *c.* 1511-1515. Washington, National Gallery of Art. Reproduced p. 94

The Vision of Prior Francesco Ottobon, oil on canvas, 121 x 174 cm, *c.* 1512-1515. Venice, Galleria dell' Accademia. Reproduced p. 154

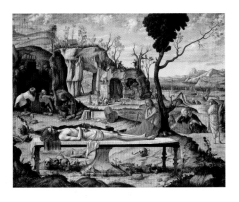

Entombment of Christ
Oil on canvas, 145 x 185 cm, *c.* 1515-1520
Berlin, Staatliche Museen, Gemäldegalerie
Reproduced p. 96, details pp. 160-161 and 164-165

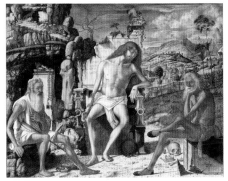

Meditation on the Passion and Resurrection of Christ
Oil on panel, 70 x 87 cm, *c.* 1508-1515
New York, Metropolitan Museum of Art
Reproduced p. 150, details pp. 63,151, 166-167 and 173

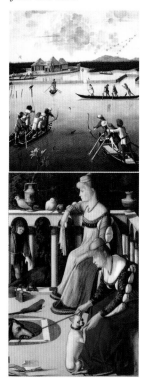

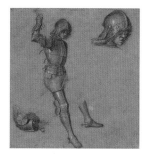

Left:
Duck Hunt and Two Venetian Ladies, oil and tempera on panel, *c.* 1490–5
Duck Hunt, 78 x 63 cm. Malibu, Getty Museum of Art. Reproduced pp. 98 and 148
Two Venetian Ladies, 94 x 63 cm. Venice, Museo Correr. Reproduced pp. 61 and 148;
details pp. 62 and 147

Above, left to right:
A fortified harbour with shipping, brown ink over red chalk on paper, 17 x 19 cm.
London, British Museum. Reproduced p. 136

Study of a seated youth in armour, grey wash with white highlights on blue paper, 19
x 18 cm, *c.* 1507. New York, Metropolitan Museum of of Art. Reproduced p. 138

Two standing women, one in Mamluk dress, Brown ink with gray-brown wash and
white highlights over black chalk, on brown paper, 23 x 12 cm, *c.* 1501–8.
Princeton, Princeton University Art Museum. Reproduced p. 139